101 GREAT SAMURAI PRINTS

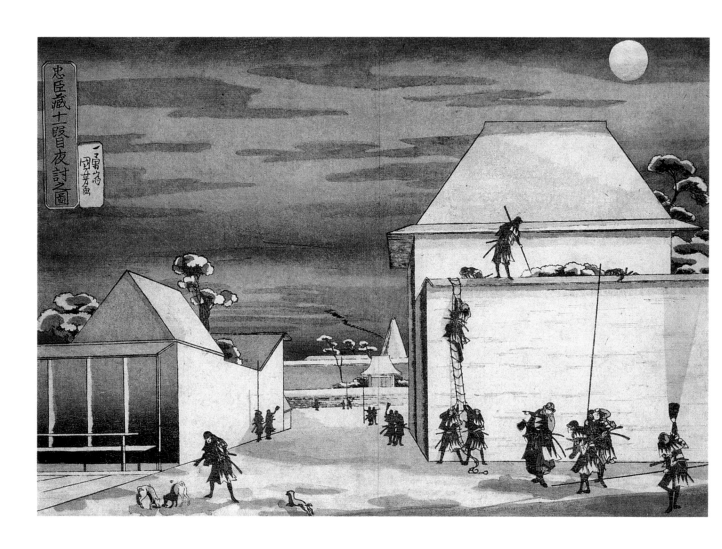

The attack of December 14, 1702

101 GREAT SAMURAI PRINTS

UTAGAWA KUNIYOSHI

EDITED BY
JOHN GRAFTON

DOVER PUBLICATIONS, INC.
MINEOLA, NEW YORK

Copyright

Bibliographical Note

This Dover edition, first published in 2008, is a new compilation of 101 Japanese woodblock prints by Utagawa Kuniyoshi, reproduced from the following original print sets: *Taiheiki eiyū den* or *Heroic Biographies from the "Tale of Grand Pacification"* (1846-47), and *Seichū gishi den* or *The Faithful Samurai* (1847-48). The Note and captions have been specially written for the present edition.

Library of Congress Cataloging-in-Publication Data

Utagawa, Kuniyoshi, 1797–1861.
 101 great Samurai prints / Utagawa Kuniyoshi ; edited by John Grafton.
 p. cm.
 ISBN-13: 978-0-486-46523-4
 ISBN-10: 0-486-46523-3
 1. Utagawa, Kuniyoshi, 1797–1861. 2. Samurai in art. I. Grafton, John. II. Title.
III. Title: One hundred one great Samurai prints. IV. Title: One hundred and one great Samurai prints.

NE1325.U78A4 2008
769.92—dc22
 2008007678

Manufactured in the United States by Courier Corporation
46523303
www.doverpublications.com

NOTE

UTAGAWA KUNIYOSHI, 1797–1861, was one of the great nineteenth-century masters of the ukiyo-e style of Japanese woodblock prints. He was born in Edo (Tokyo) and achieved his earliest great success in the 1820s with the first of his many prints of rebels and bandits illustrating a popular Japanese adaptation of a fourteenth-century Chinese novel, *The Suikoden*. Though he worked on many other subjects throughout his career, such as landscapes, beautiful women, comic and natural history prints, etc., these early dramatic subjects established his connection with the warrior prints which were one of his leading preoccupations and which are the subject of the two series reprinted in this volume. Among Kuniyoshi's many students was the major artist Yoshitoshi Tsukioka. Kuniyoshi died following a stroke on April 14, 1861.

This volume contains 101 Kuniyoshi prints, which comprise the following two series:

Taiheiki eiyū den (*Heroic Biographies from the "Tale of Grand Pacification"*), 50 prints.

The 50 prints in this series are concerned with the major warriors of the last phases of the Japanese civil wars of the sixteenth century, including Oda Nobunaga (1534-1582), the subject of the first print in the series, who worked to unify Japan under his authority but fell short of his goal when some of his supporters including Akechi Mitsuhide (print #9) turned against him and forced Nobunaga to commit suicide. It fell to Toyotomi Hideyoshi (#50) to complete Nobunaga's plan when he became, by 1590, the undisputed ruler of Japan. In this series of 50 prints Kuniyoshi portrays these powerful samurai from this complex and exciting period of Japanese history.

Some of the other major figures pictured in this series are:

#2: Imagawa Yoshimoto. One of the leading feudal lords in Japan up to his death in 1560.

#3: Shibata Shurinosuke Katsuie. One of Nobunaga's commanders. During the intrigue following Nobunaga's death, he was defeated by Hideyoshi's forces and was forced to commit suicide.

#11: Sakai Ukon Masanao. A retainer of Nobunaga, killed at the battle of the Anagawa, 1573.

#35: Hayashi Hanshirō Taketoshi, a retainer of Akechi Mitsuharu (#31). They were defeated by Hideyoshi at the battle of Uchide-hama, 1582.

#39: Oda Nobutaka. The third son of Nobunaga, he attempted to avenge his father's death, but fell into the hands of his enemies and under pressure from Hideyoshi and others, ended his life a suicide.

Seichū gishi den (*The Faithful Samurai*), 51 prints.

The 51 prints in this series portray all of the major figures in a true tale of samurai bravery and heroism which has always been enormously popular in Japan, the story of the 47 "rōnin," or masterless samurai who avenged the death of their lord though knowing that

their actions were likely to lead, as proved to be the case, to their own deaths. It is a story which defined *Bushido,* the "Way of the Warrior," the samurai code stressing loyalty, martial arts, and honor unto death.

The first two major protagonists in this story were Kōno Musashi no Kami Moronao (see print #88), a high official in the shogunate at the end of the seventeenth century, and a powerful feudal lord, En'ya Hangan Takasada, Lord Asano (#89). While Moronao was instructing Asano and another feudal lord in the particulars of court etiquette, he insulted Asano in public in a way that the latter found intolerable. Ultimately Lord Asano drew his dagger and attacked Moronao, but only wounded him slightly.

However, he had committed a grave offense by drawing his weapon inside Edo Castle, the Shogun's residence, and was arrested and ordered to commit *seppuku* for doing so. He complied with this order and following the law and customs of the time, his lands and goods were confiscated, his family ruined, and his retainers became rōnin, or masterless samurai.

Under the leadership of Ōboshi Yuranosuke Yoshio (#51), the rōnin bided their time, and, pursuing many other occupations as a cover, migrated toward Edo and became familiar with the workings of the mansion in which Moronao lived. Finally, after more than two years had passed, they attacked the mansion in the early morning of December 14, 1702. Divided into two groups, they attacked both the front and the rear gates, killed sixteen of Moronao's retainers and, with archers posted on the roof to prevent messengers from the mansion from summoning help, gained control of the mansion. Women and children were spared. The attackers ultimately found Moronao hiding in a storage area, offered him the opportunity to commit suicide and when he declined, decapitated him.

One of the rōnin was dispatched to travel to the area formerly ruled by Asano with the news of their successful revenge, while the others took the head of their enemy Moronao to Asano's grave at Sengakuji Temple. The rōnin then surrendered to officials of the Shogun. They were placed under arrest and divided into four groups, each under the authority of a different *daimyō* or feudal lord. While the rōnin had followed the precepts of *bushido* by avenging their Lord, they had defied the Shogun's authority by taking revenge against their Lord's enemy. Ultimately the rōnin were ordered to commit *seppuku,* which 46 of them did on February 4, 1703. The rōnin who served as a messenger was pardoned, perhaps because of his youth. He lived to be 78 when he was buried where his 46 comrades were interred with Asano at Sengakuji Temple.

The 51 prints in the series portray all of the 47 rōnin as well as Lord Asano (#89), and their enemy Moronao (#88). The subject of #68, Teraoka Hei-emon Nobuyuki, was not actually a samurai, but was allowed to take part in the famous attack because of his loyalty to the Asano clan. He was not required to commit suicide after it. The final print is of one of the rōnin's faithful retainers.

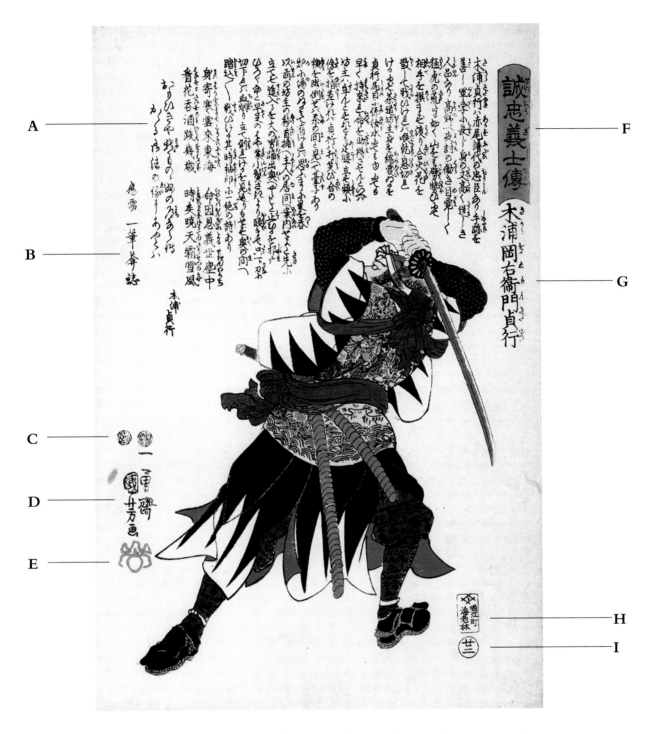

This print is a diagram to the parts of the prints in these two series.
A. Text. **B.** Text author. **C.** Censor's seals. **D.** Artist's signature. **E.** Artist's seal. **F.** Series title. **G.** Print title. **H.** Publisher's seal. **I.** Series number.

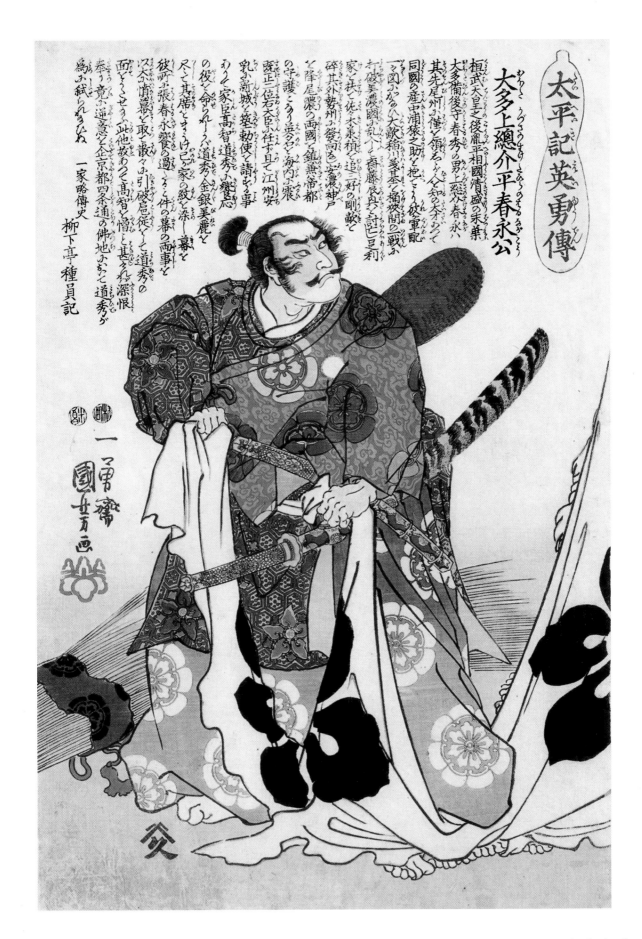

太平記英勇傳

大多上總介平春永公

1. Oda Nobunaga. Samurai Oda Nobunaga in a moment of focused rage, tearing down a tent curtain decorated with the crest of his treacherous vassal Akechi Mitsuhide. He wears the samurai's traditional dual swords, one longer and one shorter, and carries a quiver of arrows on his back. The tiger fur covering his long scabbard confirms Nobunaga's high status as a warlord.

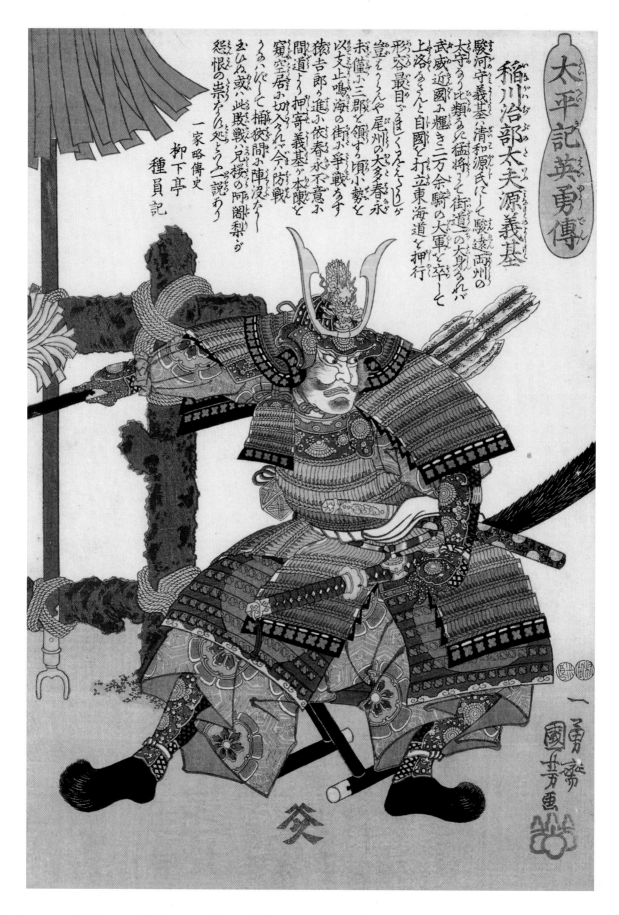

2. Imagawa Yoshimoto. Yoshimoto is shown holding a samurai commander's *saihai*, a baton, in his right hand, and wearing a helmet decorated with fierce-looking horns. Standing in front of a wooden stockade, confirming that this is a battlefield scene, Yoshimoto's posture and expression convey the anxiety which even the fiercest samurai could feel in the face of an approaching enemy. Yoshimoto was indeed killed in battle. On the left, tied to the stockade, is the samurai's *yaguraotoshi,* a long-handled weapon used in attacking castles that ends in a crescent-shaped metal point.

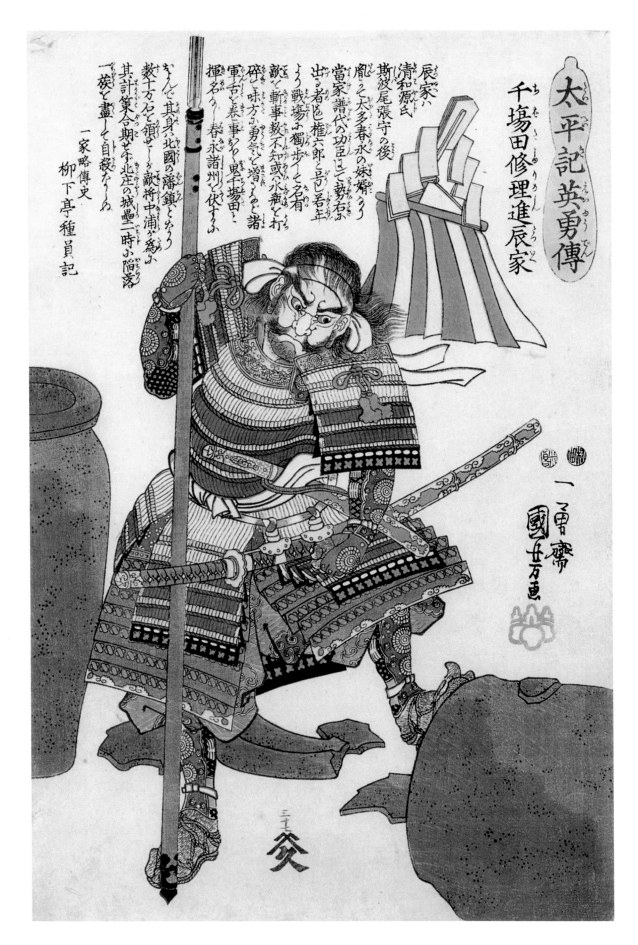

辰家ハ
清和源氏
斯波尾張守の後
胤にて太多春水の妹婿なり
當家譜代の功臣として勢右に
出る者なし権六郎と呼ひ君年
よう戦場ふ獨歩かくて名有
敵事数ふ斬事数不知或ハ水瓶を打
碎て味方の勇気と増すなと鬼千塲田と
揮名り春永諸州と伏するに諸
軍舌を巻ひ事とり
んて其身北國の藩鎮となう
数十万石と領せしか献将中浦か為ふ
其計算合期末北庄の城塁一時か陥落
一族と盡くして自殺なるの

一家略傳史
柳下亭種員記

3. Shibata Shurinosuke Katsuie. Shibata is depicted destroying his own troops' water vessel, an act he indeed carried out to focus his warriors' spirits in a successful battle. Above the samurai's left shoulder is his personal standard, decorated with paper streamers.

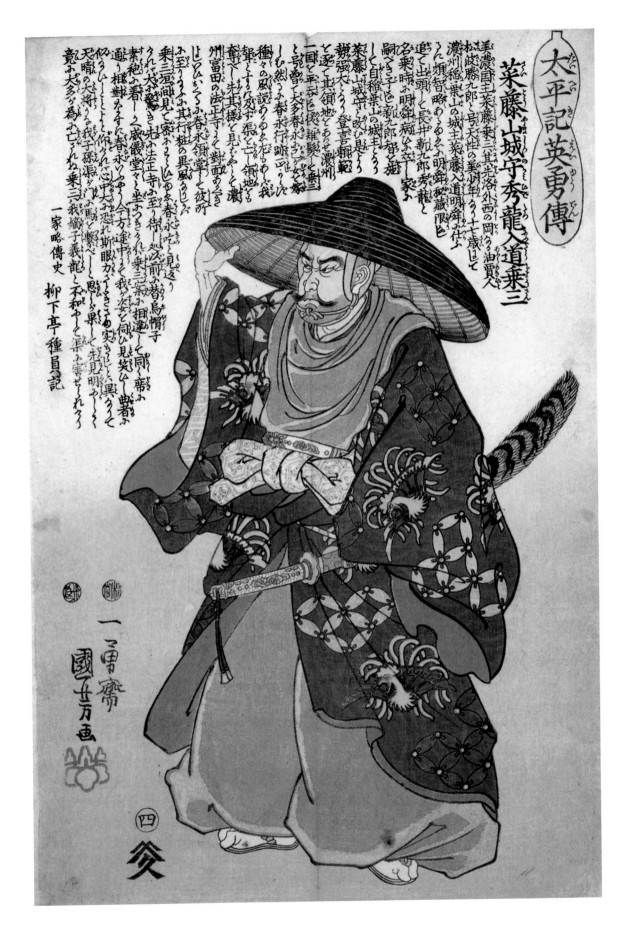

太平記英勇傳

斎藤山城守秀龍入道乗三

一家略傳史

柳下亭種員記

4. Saitō Toshimasa nyūdō Dōsan. The samurai is wearing a large hat to facilitate spying on Oda Nobunaga in a situation away from the battlefield—Saitō was trying to determine for himself if Nobunaga would make an acceptable son-in-law. The richness of his cloak's decoration, as well as the tiger fur scabbard, confirm Saitō's status as a powerful warlord.

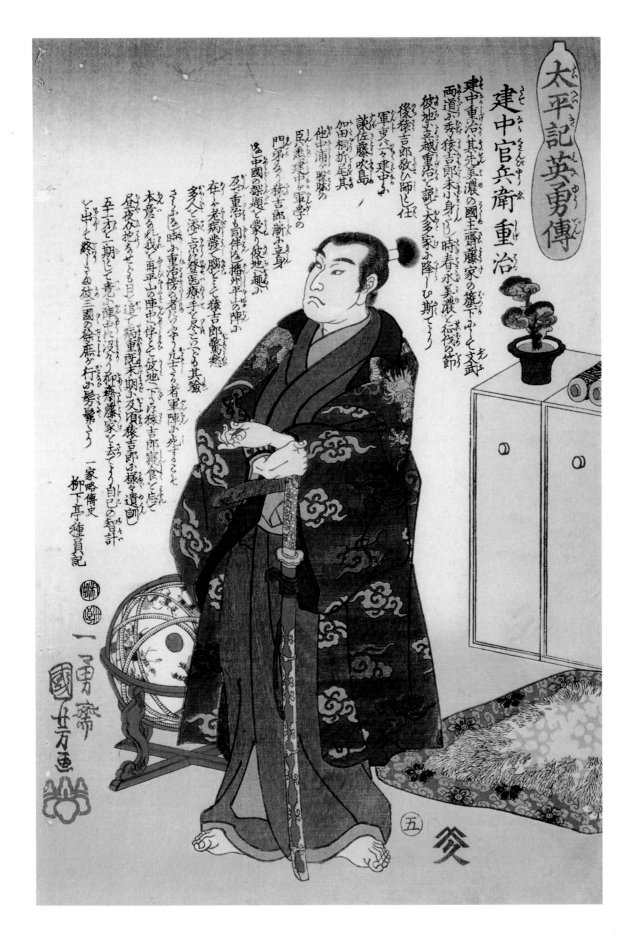

太平記英勇傳

建中官兵衛 重治

建中重治ハ其先美濃の國主齊藤家の麾下ふして支武
両道ふ秀ぐ猿吉郎未小身ふし一時春永美濃と征代の節
彼地ふ玄越重治と説ひ犬多家ふ降ーむ斯てぅリ
後猿吉郎敎ひ師と仕
軍吏ハ々建中ふ
諫佐藤吹島
加田桐折尾其
他中浦ふ整勝の
臣流建中ふ軍子の
門弟ぁり猿吉郎薪小辛身
ふ中國の類類と築り彼地ふ趣か
及で重治も同伴ほ播州平山の陣ふ
在ゕ老病歿で胸とと々猿吉郎驚愕
多人と添て京ふ登医療手を尽くどくも其驗
さらふ々時ぉ重治傍の者らぉや々え々らる者軍陣ふ亡セくると
本意されれ我と再平山中ふ伴ぅと彼地ふ下られ猿吉郎寢食と忘し
昼夜ふ抱ぁゼゐせども日と追て病院末期ぉ及ぅ猿吉郎ふ樣々遺訓
五十一才と一期として青ぅ陣出ふ没りぬ花齊藤家と去て々自巳の智計
と出て終ーゐ々彼三國の發席ぉ行ぉ房驛ぅろぅ
　一家略傳史
柳下亭種員記

一勇齋
國芳画

5. Takenaka Hanbee Shigeharu. Takenaka is surrounded by the attributes of a highly intellectual advisor to a military commander, including the scrolls on the sideboard and the celestial globe in the armillary sphere. Study of the disposition of heavenly bodies played a major role in the planning of the samurais' military actions, confirmed here by the stars in the night sky above the interior scene.

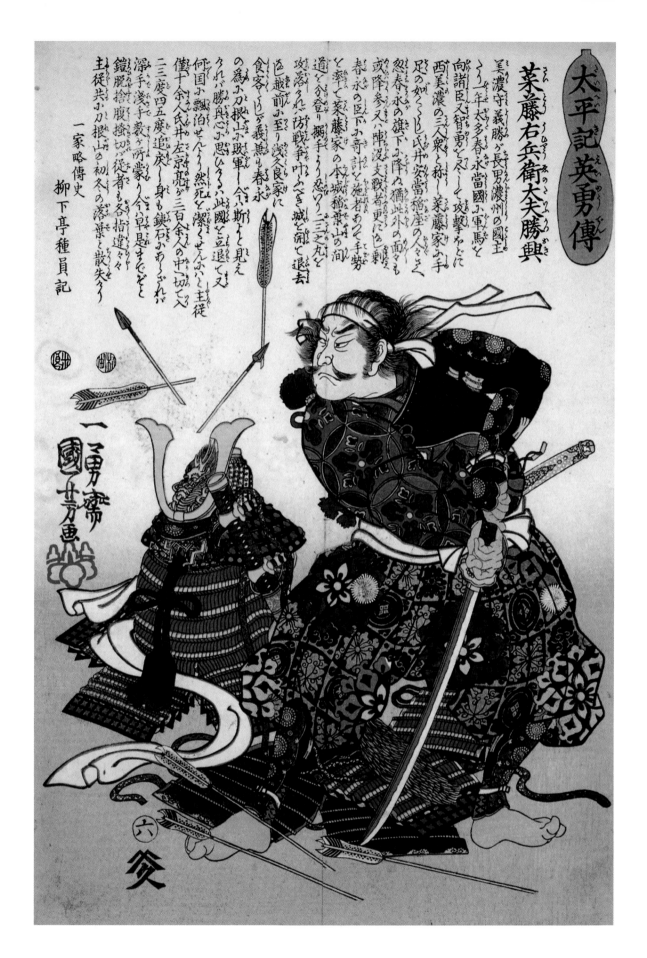

太平記英勇傳

菜藤右兵衛大夫勝興

美濃守義勝が長男濃州の國主
うし一年太多春水當國小軍馬を
向諸國臣又智勇を尽して攻撃などに
西美濃の三人衆の手
足の如くし氏井安當稻座の人々さ
或降參又八陣沒支戰者にし剩
忽春永の旗下小降な猶此外の面々も
と率て菜藤家の本城稻葉山の間
春水の臣下小奇計を施者あぞ手勢
道を豫登り攔手よう恐り三之丸を
攻惑され防戰叶ふべき城を前て退去
已越前小至り淺久良家に
食客とし春燕も
の為ふ刀根山も春永
れども勝咫に見ふる思ひろる
何國小飄泊せんよう然死と
僅十余人氏井左京亮が三百余人の中に切てく入
二三度四五度ぞ追炎小身も鍥石かあぐれが
深手淺手數ヶ所家し今小卓是まどゞさ
鎧脫捨腹搔切從者も各指違々
主從共小刀根山の初冬の溶葉と散失りり

一家略傳史
柳下亭種員記

6. **Saitō Uheenotayū Tatsuoki.** The samurai seems to be successfully warding off enemy arrows with his sword, but the helmet and armor on the ground beside him indicate that the warrior knew the end was near. In a hopeless situation with his troops outmanned, Saitō Tatsuoki removed his armor and committed suicide.

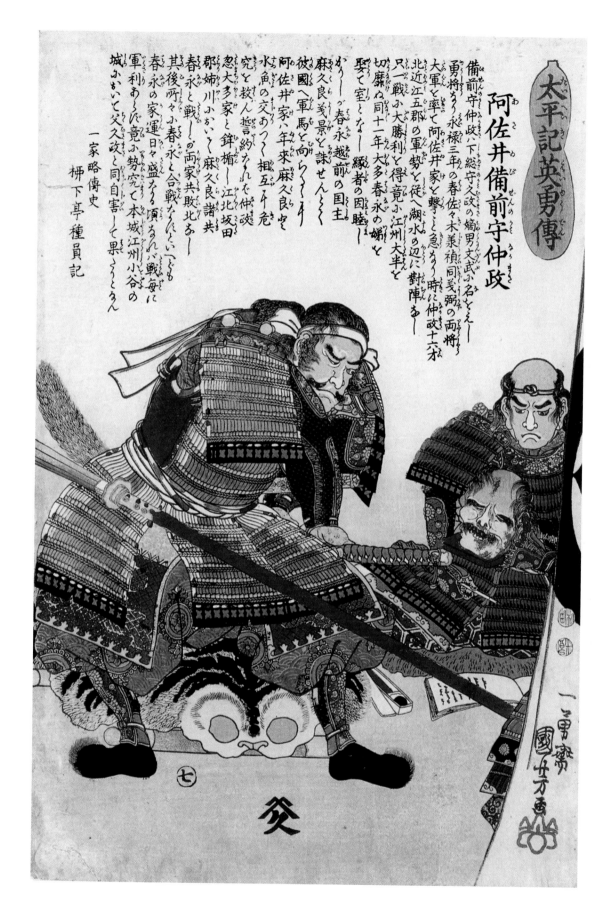

阿佐井備前守仲政

備前守仲政ハ下総守久政の嫡男丈武小名をえ
勇将なり永禄三年の春佐々木義禎同義弼の両将
大軍を率て阿佐井家を撃とぞ急ぐ北近江五郡の
北近江五郡の軍勢を従へ湖水の辺に對陣あり
只一戰ふ大勝利と得竟ふ江州大半を
切靡ふ同十一年大多春永の嫌と
娶て室となー縁者の圍睦
かりーっ春永越前の国主
麻久良義景と誅せんとく
彼國へ軍馬を向らーーー
阿佐井家八年来麻久良と
水角の交あつく相互に危
究と敢ん誓約なりを仲議
其後所々春永と合戦なれど戦毎に
郡姉川ふかいて麻久良諸共
春永と戦ーーの両家共敗北あー
春後の家連日々盛たる頂れバ戦毎に
軍利あらバ竟ふ春永と勢究ふて本城江州小谷の
城ふかいて父久政と同自害して果ううとうん

一家略傳史
柳下亭種員記

太平記英勇傳

7. Asai Nagamasa. Sitting on a campstool covered with a tiger pelt, Asai turns toward the source of the spear being thrust in his direction from the lower right. Another samurai sits behind him holding the severed head of a defeated enemy, no doubt for presentation to his commander. Holding a writing implement in his right hand, with paper on the ground before him, this warrior may either be preparing to compose a record of the battle just ended, or writing a farewell poem, an act often preceding a samurai's suicide as might be required by what happened on the battlefield that day.

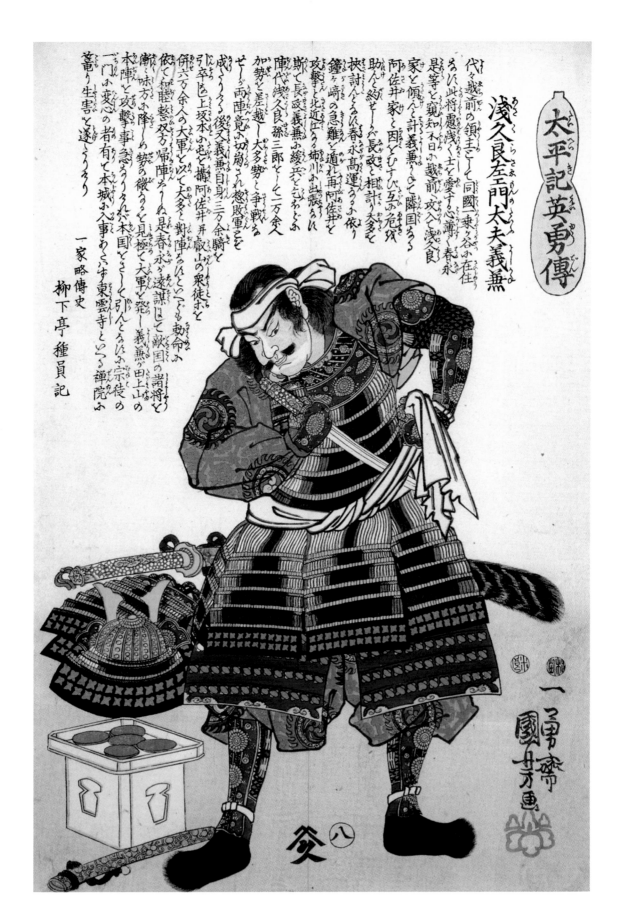

太平記英勇傳

浅久良左門太夫義無

8. Asakura Saemonnokami Yoshikage. Continuing a theme which runs through many of Keniyoshi's samurai prints, Asakura Yoshikage prepares to commit suicide after finding himself in a hopeless battlefield situation, betrayed by his vassals and his household. After placing his helmet and armor on the ground, the samurai is cutting away his garments. At the lower left is a portable table with cups for sake, perhaps to be used at a ceremonial farewell feast prior to the final act of suicide.

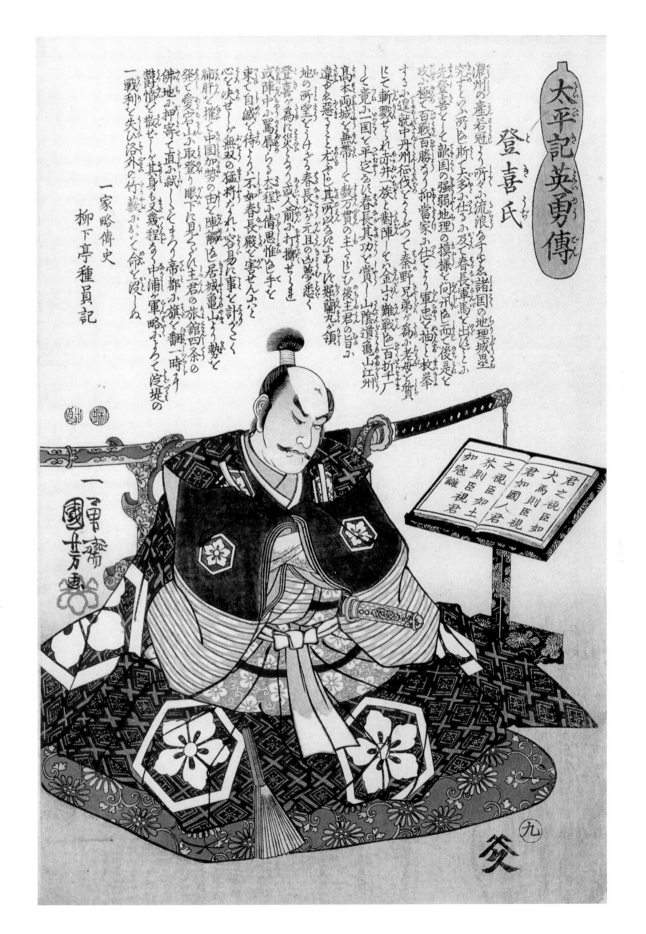

9. Akechi Mitsuhide. The samurai in repose with the elegant accoutrements of a warrior. The book on the lectern is open to a text by the Chinese philosopher Mencius concerning the consequences of a ruler's disregard of his subjects, no doubt a reference to the cause of Akechi's revolt against Oda Nobunaga, one of the key events of this period. Akechi's *katana,* his longer sword, is on the elegant rack behind the seated samurai.

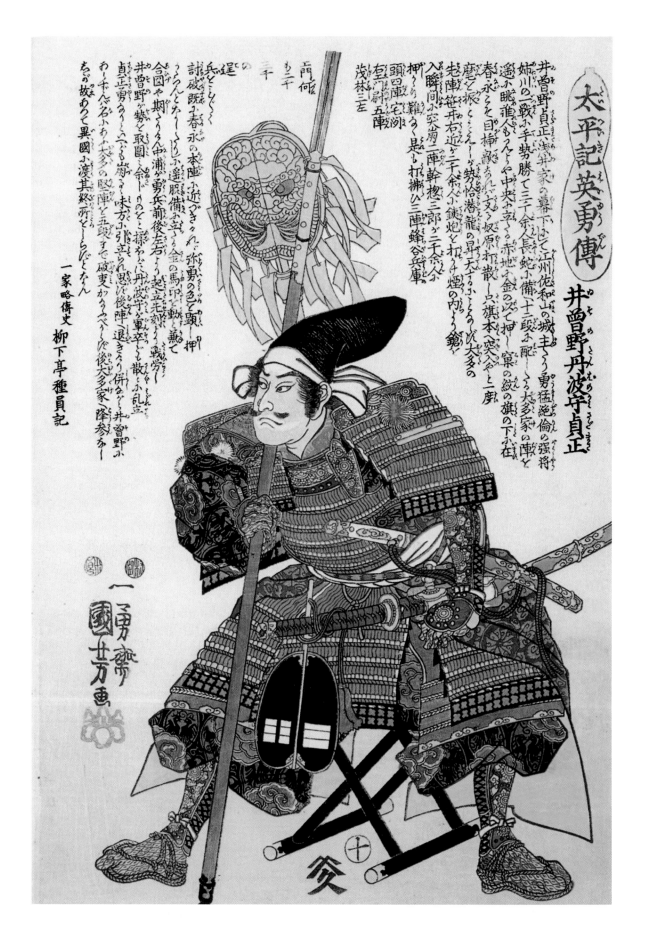

10. Isono Tanba-no kami Kazumasa. The samurai is sitting on his campstool in front of his *sashimono*, his personal standard in the shape of a lion's head with golden strips representing the mane. The commander's fan hanging from his long sword is decorated with cosmological signs from the *I Ching*, reflecting the philosophical knowledge expected of an intellectual military thinker.

太平記英勇傳

笹井右近尚直

笹井尚直は久蔵尚保の父やして

一国斎
國芳画

太多家の良臣なる春永浅井朝倉と比叡山の麓に對陣うすとて両月余り越前うの湖に積来朝倉家の兵粮来堅田浦へ積置うれば右近尚直是をミて率や敵の粮来を奪んとて堅田の住人猪飼甚助馬場孫次郎等を案内者とし二手勢五百余人密に船ふ取乗て堅田浦へ押渡り夜半もすぎんとおもふ頃ハ朝倉家の番兵等ハ思設ぬ事なれハ皆散々に迯失うて粮米をふ船ふ積されゝ右近心の儘に切立らるゝわれ身の乗べき船ふ走せ再廻掉を待所ふ先ゝ迯去兵卒等ふ是ふ依て浅井朝倉両家の軍勢五十余騎兵船数艘漕連直ふ浦辺ふ行上り勢の笹井直ふ取篭て微塵ふせんと搦立る右近ふ軍勢男ふいかで水の助の兵なるけれハ八発ふ討死う尚直ふ

春永の本陣へ送り身の乗べき船ふあけ

一家略傳史
柳下亭種員記

11. **Sakai Ukon Masanao.** The samurai depicted is in a heroic and ferocious pose, his sword out of the scabbard and ready as he turns to face the enemy which pursues him. The dragon on his cloak is a symbol of invincible power. Following a brutal defeat, however, Sakai Masanao committed suicide on the battlefield.

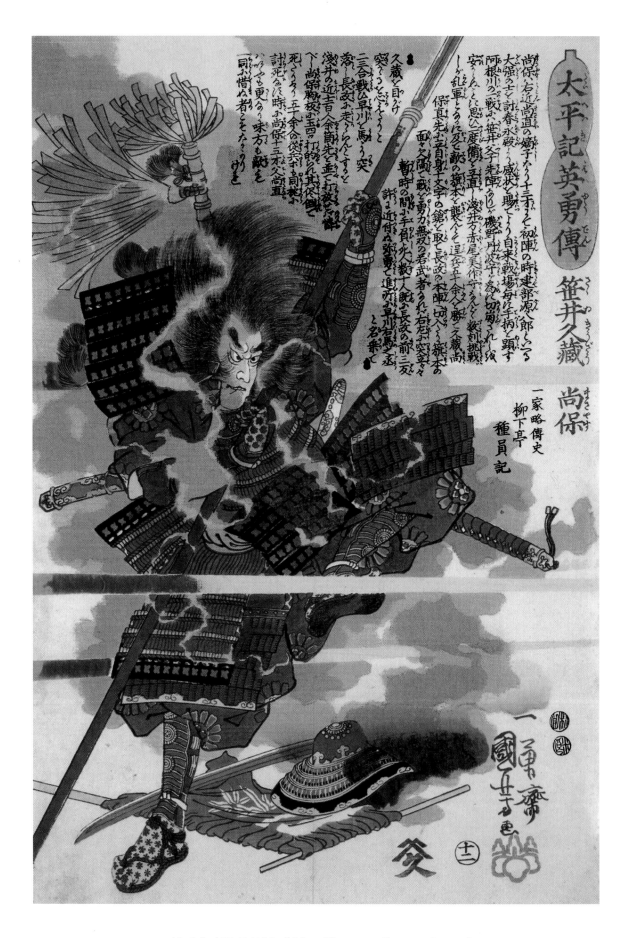

12. Sakai Kyūzō Narishige. The samurai's expression and posture reflect his indomitable fighting spirit, but the helmet, standard, and sword lying on the ground in front of him indicate that this battle has been lost.

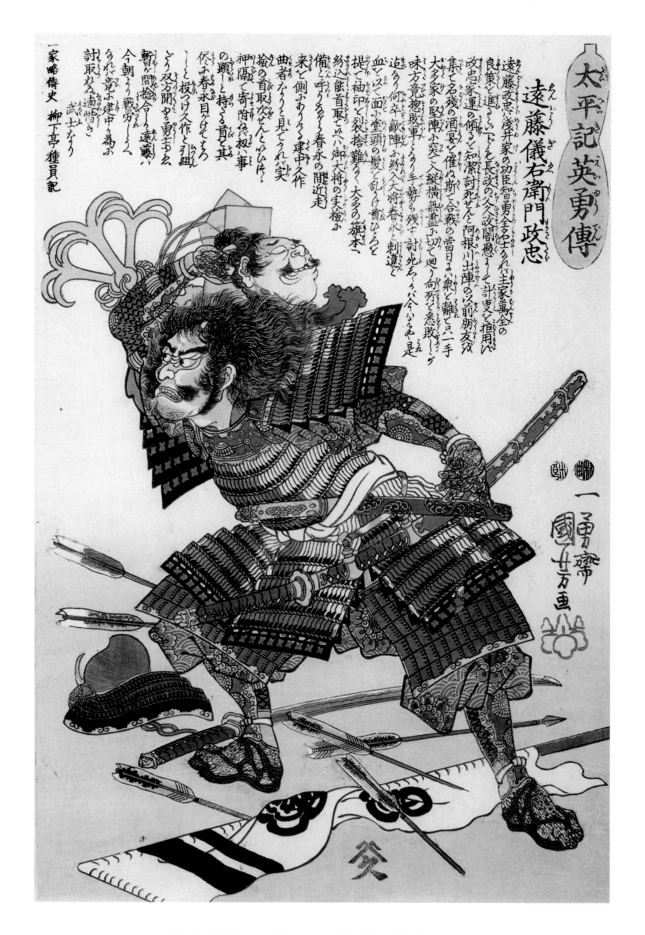

13. Endō Kiemon Naotsugu. Warding off a heavy arrow barrage, Endō is preparing to return fire with the severed head of an enemy warrior. The multi-hooked weapon above his right elbow is a *kumade*, or bear's clutch.

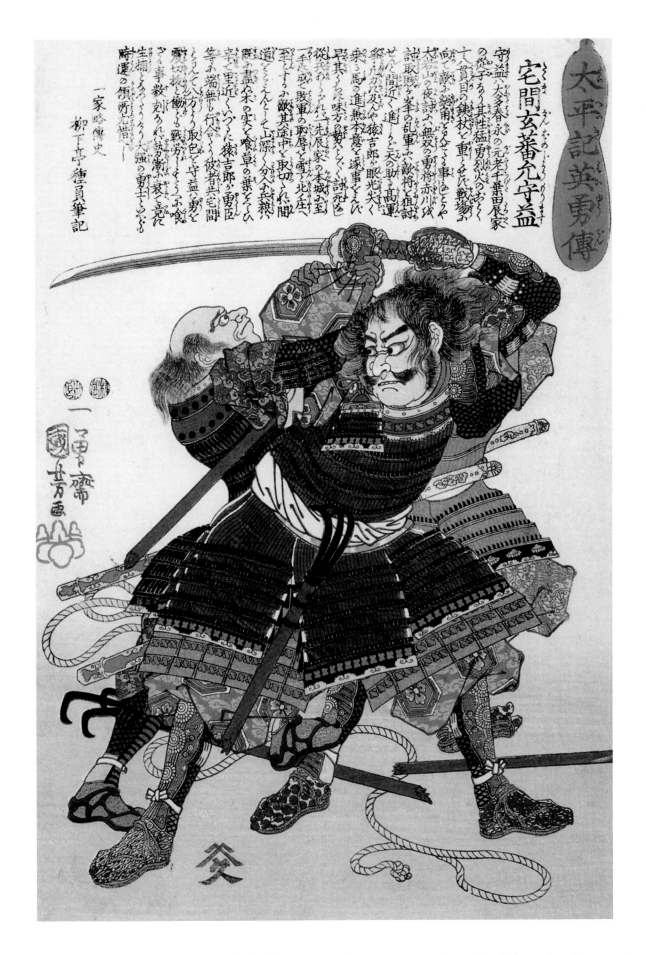

宅間玄蕃允守益

守益は太多春永の元老千葉田辰家の従子太多春永の元老千葉田辰家の子其性猛勇烈火のおくて丁寶目の鍼秋と重々せ日々戦場の向ふに敵ふところなくつくと太刀山の夜討の無双の勇将赤川城詰取訓ケ峯の乱軍中か敵将を狙討せんと間近くか進むや猿吉郎か眠光失く乗馬の進無本意とく球事とん申其方一味方の籔やとくく論死その従軍の取辱と雪に北を至すれに先辰家の本城の至一手に威て敗軍の取辱を雪に北より遣すれか其途中に取切られ辛く里近くいつた猿吉郎か守益等のいか取とる彼者共働てらへんとうり力々取包み守益か勇を愛し戦労らしの一も戦草の葉を喰ず勇を愛し戦労らしの一も戦草の葉を喰歎其志栄の実と喰草の葉を喰ずく蓋余勇か大強の勇士とく生捕られよ近方衛す哀て亡さに崎遇の傾咄九惜し

一家略傳史
柳下亭種員筆記

14. Sakuma Genba Morimasa. In this lively print Kuniyoshi depicted Sakuma being arrested by the henchmen of his enemy Hideyoshi. At first glance it appears that only one opponent is attacking Sakuma, but there are six feet visible in the picture, indicating that at least two men were needed to take on the powerful samurai.

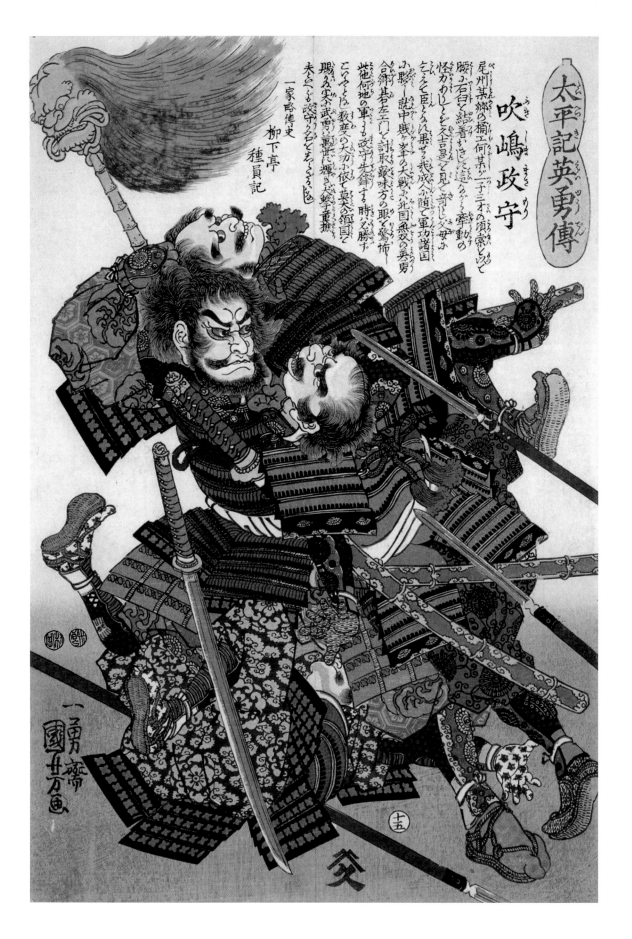

15. Fukushima Masanori. Masanori is in close combat with three opponents simultaneously. The samurai's fierce expression is mirrored by the mask at the top of his personal standard.

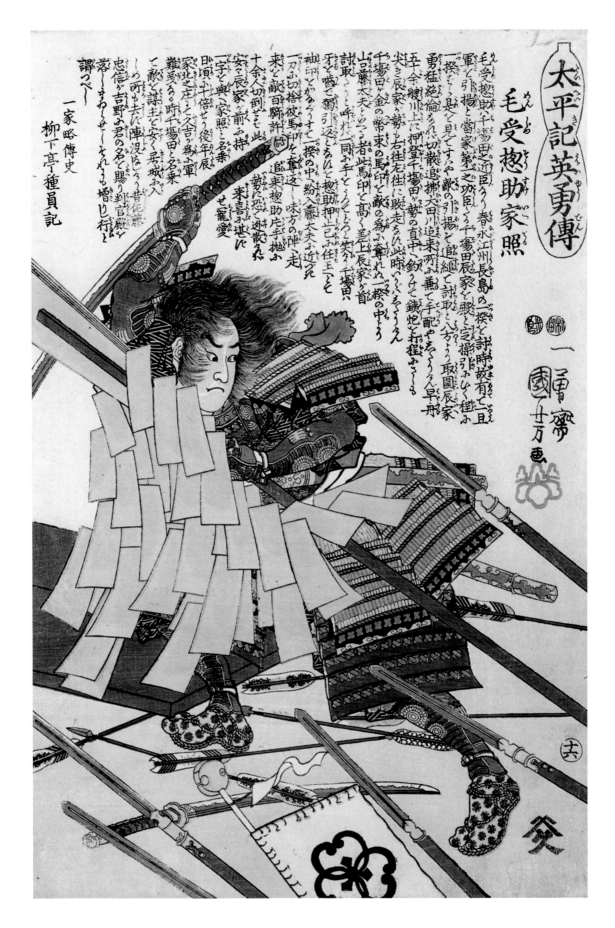

16. Menju Shōsuke Ieteru. Under a fierce spear attack by unseen opponents, the young samurai Menju Ieteru has successfully retrieved the signpost of his lord, decorated with many strips of gold paper, from the hands of their enemies.

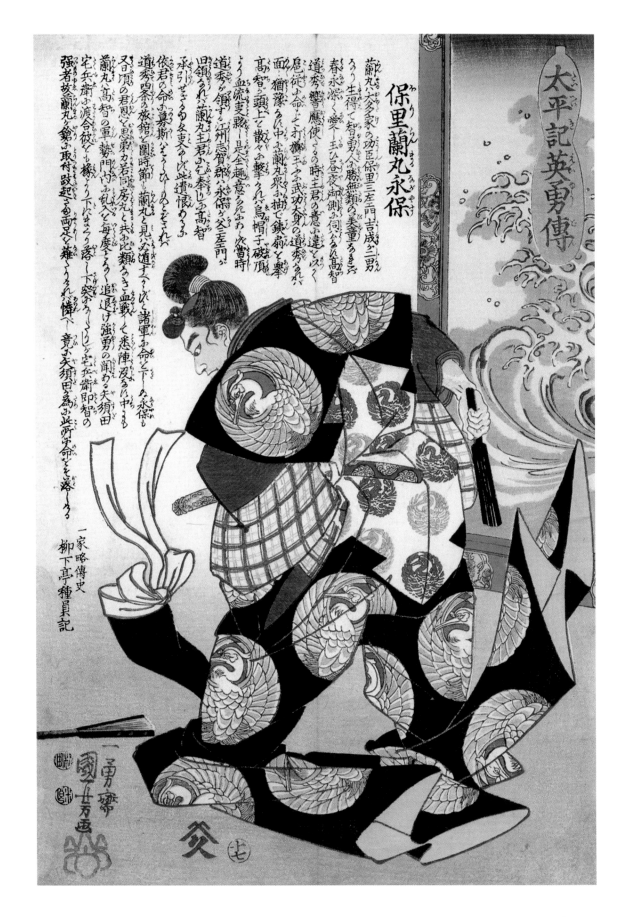

太平記英勇傳

保里蘭丸永保
やりうえんまるながやす

蘭丸六々多家の功臣保里三左エ門吉成が三男
らう生得て智勇人に勝無類の美童ろきよぶ
泰永深く愛て智勇人に勝無類の美童ろきよぶ
道秀響應使ぐるの時主君の意ふ違とにく
息從に命じと打擲す武功大㒟の道秀がれが
面・獨藩らんの中ふ蘭丸界ふ抽で鍊翁を撃
高智が頭上て散々ふ撃ゆ烏帽子破頂
よく血流支聽―是全越意くふふ次當時
道秀が領す江州志賀郡ふ永保ふ冬三左エ門
田領の君恩と思弟力若ふ房丸と共ふ比類なき血戰
及頂の君恩と思弟力若ふ房丸と共ふ比類なき血戰
蘭丸が見ふ道すこと諸軍ふ命と下ぬ永保
承られふ蘭丸主君ふ奉じり高智
承る君の命と下ふ一るよ落一下突ふ
依君の命との蓦斯ぞうふくじ此遺憾わふ
道秀が西条の旅館と闘時節
田領の君恩と思弟力若ふ房丸と共ふ比類なき血戰
道秀が四条の旅館と闘時節
追退け強勇の聞わる矢須田
蘭丸高智の軍勢閉付ふ乱入と每度ぞろく
宅兵衛ふ渡合令彼と樣うふ落一下突ふ
強者蒼蘭丸が鎗ふ取付跌起る兩足と難ふられば
懴ふ意ふ矢須田ゐ為ふ此所ふ命とを落し―る

一家略傳史
柳下亭種員記

17. Mori Ranmaru Nagasada. The *fusuna,* a decorated sliding screen, seen at right, confirms that the samurai Mori Ranmaru is engaged here with an opponent inside a castle. The elegantly dressed samurai has just, at his lord's command, struck his unseen opponent with the metal fan he holds in his right hand. The victim of this attack, Akechi Mitsuhide, has lost his hat which is seen floating, decorated with ribbons, on the left, and dropped his own fan at Ranmaru's feet.

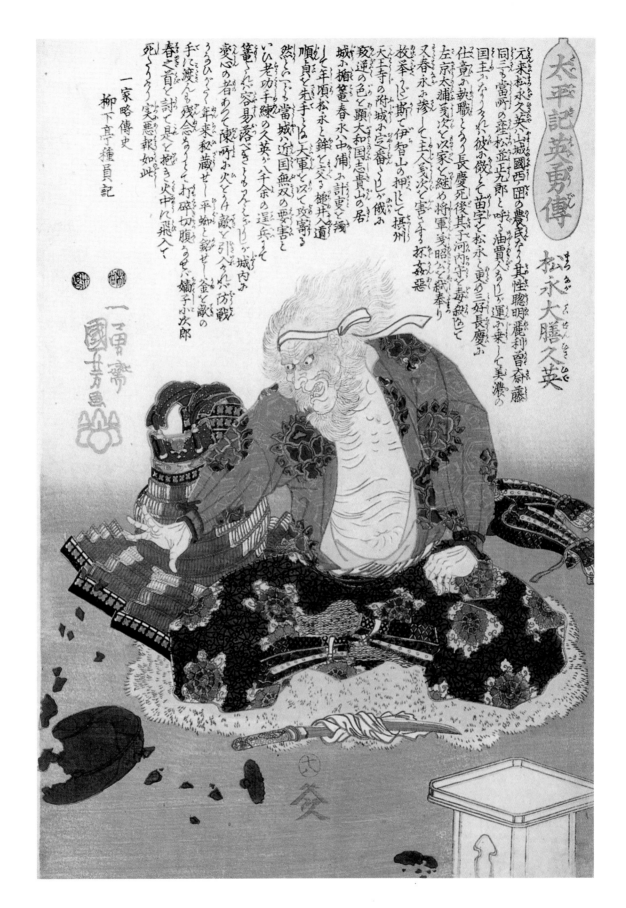

18. Matsunaga Danjō Hisahide. Samurai Matsunaga Hisahide about to commit *seppuku* when facing defeat by an insurmountable opposing force. The 67-year-old warrior, seated in the appropriate position, has removed his armor and shattered a cherished tea ceremony vessel to keep it from falling into his enemy's hands. The knife with which he will kill himself is on the ground in front of him, its blade wrapped with a cloth to prevent it from penetrating farther into his abdomen than called for by the requirements of the ritual. Generally, as soon as the samurai had plunged the knife into his abdomen, he would be decapitated by a comrade.

太平記英勇傳

尼中鹿之助幸盛

19. Yamanaka Shikanosuke Yukimori. The samurai in full regalia stands by a body of water, hands clasped in a prayerful position, gazing at the crescent moon, its shape recapitulated in the decorations on his helmet and at the top of his standard. The blue and white cloth object attached to the back of his armor is a *horo*, designed for protection against arrows.

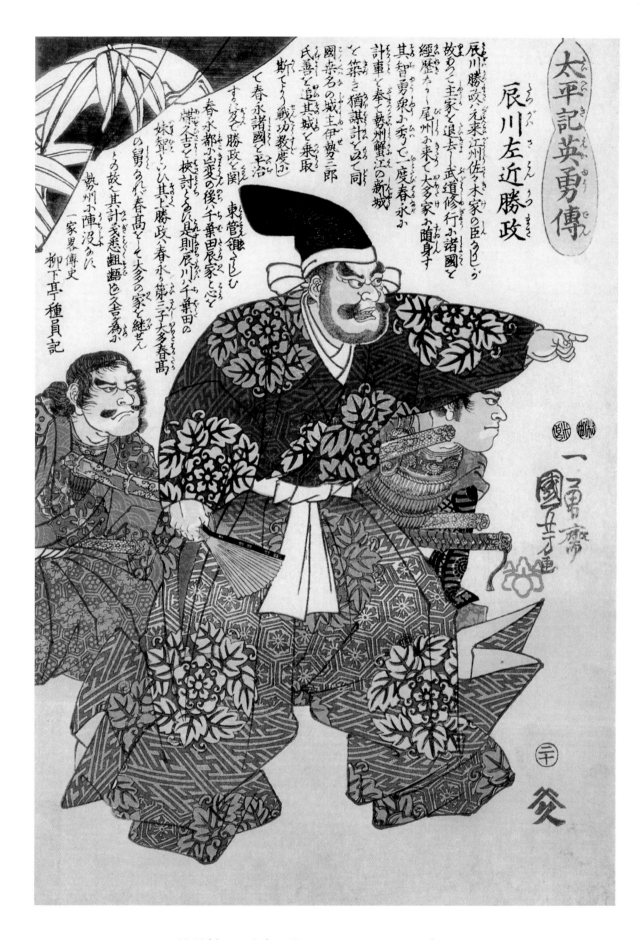

辰川勝政ハ元來江州佐々木家の臣なりしが
故ありて主家を退去し武道修行の為諸國を
經歷なし尾州に来て大多家の顧身す
其智勇衆のに秀て一度春永か
計事を奉し奄州蟹江の新城
國奈名の城主伊勢三郎
氏善を追其城を乗取
斯てう戰功數度に
すること多で勝政と關
春永都に出変の後千葉田辰家と心と
懐久吉と狭討とらん是則辰川八千葉田の
姊聟さられ其上勝政ハ春永か第三子大多春高
の舅なれバ春高をして大多の家を継せん
との故し其計議悲趣醤と久吉ら為か
勢州小陣沒かれ
一家琴傳史
柳下其亭種員記

辰川左近勝政

20. Takigawa Sakon Kazumasu. Not wearing the samurai's armor in this print, but still holding his commander's fan in his right hand, the powerful Kazumasu forcefully directs his subordinates with his left.

槌井大和守入道順貞

元来大和国三郡の領主〳〵品〻左近将監倉右近といへる羽翼の臣わりて武備尤嚴なり嘗て山陰道亀山の城主登喜と、舊友〳〵依て登喜其主君春長お申槌井を〳〵て大多の旗下に〳〵ひ斯して妻先鋒小進と荒樹村重が攝州伊丹の里と拔松永久秀が利州志貴の城を破り意知山の搦と〳〵数万騎と對陣〳〵て聊と臆する色なく武威日〻に增長をせば春長順貞と〳〵大和一国の主となす斯て登喜四条の佛地かおいて主君と刺〳〵奉り此頃和州小使者と書ていふ日頃の樹憤難止春長殿と討取畢ぬ貴君年来の因と思ひて日頃の合戦小助かおいて八戦功の後奮領大和か外二ヶ国と侍て已四男小黄金許多とうろ〳〵即相違わろうらふ〳〵の誓ふろうとて是か領せざ入道心決せよ渚臣の異見と〳〵り時小〻品〻左近友行進出某返答すへしと使者に對面色相違あらぐ〳〵乃ち進逐三承知仕御味方おいて〳〵即時か二万余騎の軍勢お催渡〳〵返きや敵軍と戦壊と約せ〳〵浸堤の彼方ろ〳〵洞せ峠よ率て登喜か敵軍と戦壊と約せ〳〵順貞自身か是とお既か登喜ヶ軍利と失ふ及で惣軍本坡て入道討うと共ふ勝利ととくろうとぞ卿の京童の口さぶろ〳〵つて是よう順貞とく揮名と日和親の法師と号〳〵とちん

一家略傳史
柳下亭種員記

21. **Tsutsui Junkei.** Holding his commander's fan tightly with both hands, Tsutsui appears deep in contemplation of a fateful decision. His longer sword is stored in a tiger fur sheath by his side. Tsutsui's shaved head confirms that in addition to being a warrior, he is also a Buddhist lay monk.

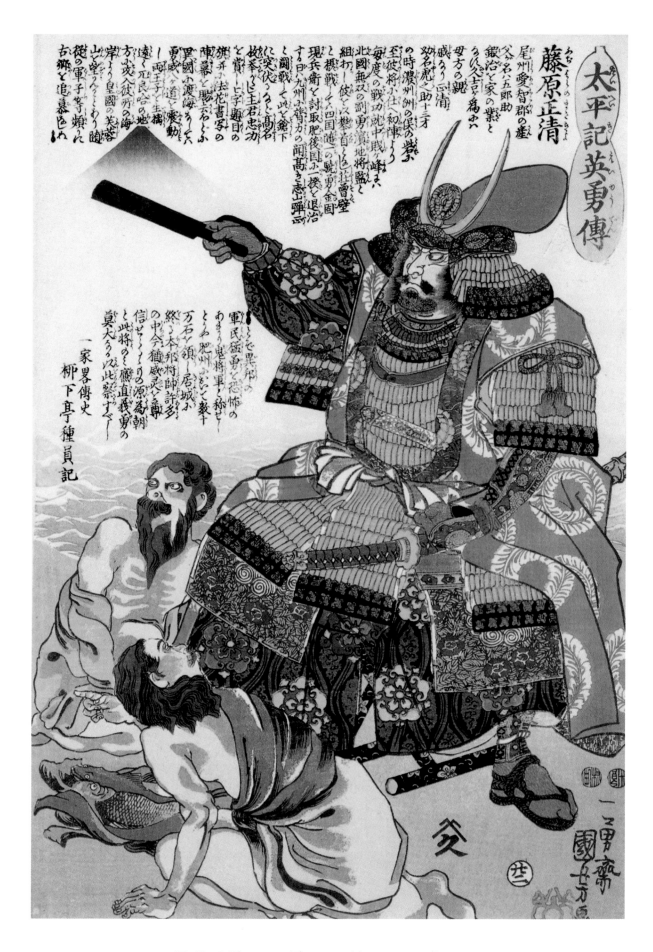

22. Katō Kiyomasa. The samurai in a commanding pose
during a campaign in Korea in 1592. Two native fishermen,
dressed only in rags, are at his feet.

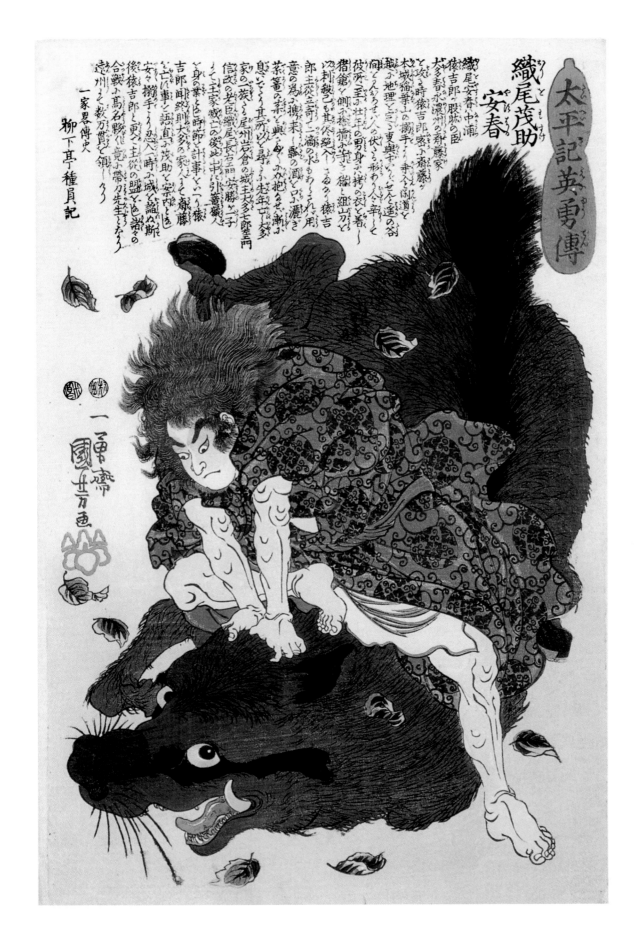

23. Horio Mosuke Yoshiharu. Horio Yoshiharu was a young warrior who retreated into the woods and lived as a hunter following the downfall of his first lord's house. Here, with no weapons, he is in hand-to-hand combat with a gigantic wild boar. After this incident he formed a connection with a new lord and made a dramatic comeback as a samurai, successful in many battles.

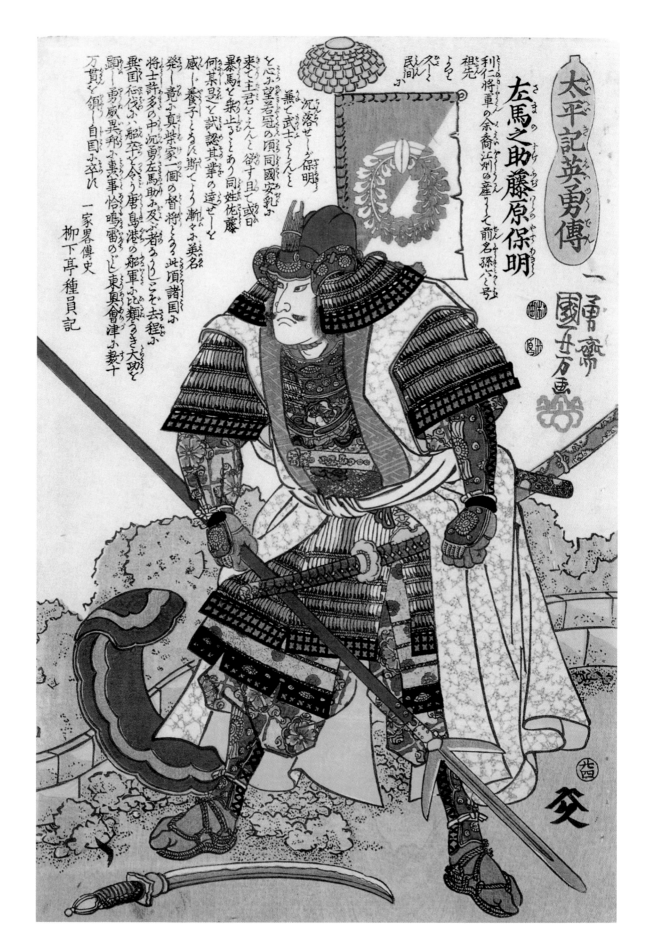

太平記英勇傳

左馬之助藤原保明

一勇齋
國芳画

24. Katō Samanosuke Yoshiaki. The determined samurai, in full battle armor ready for action, stands on a walled fortification, spear in hand.

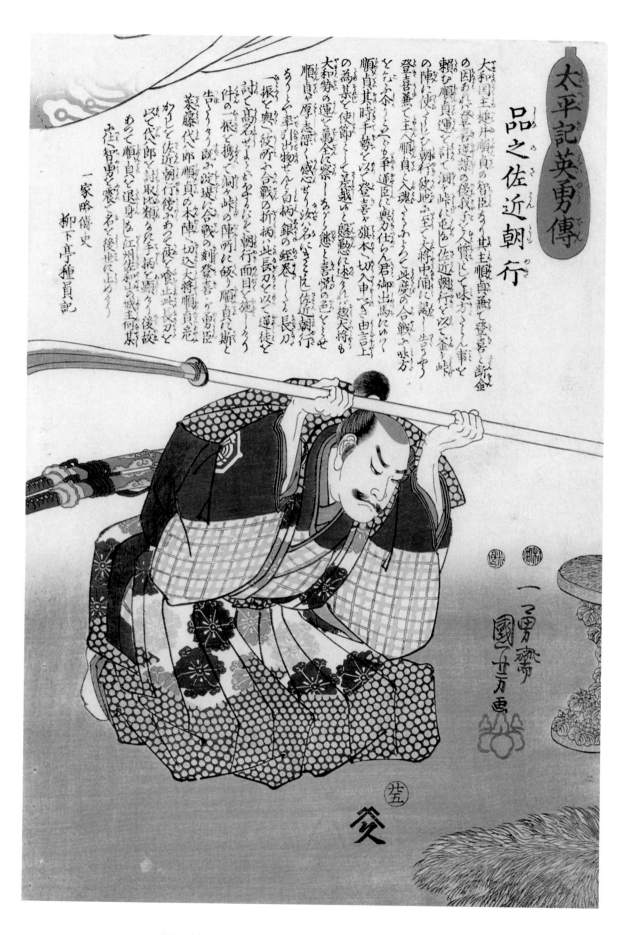

25. Shima Sakon Kiyooki. The samurai in a humble position, receiving a gift from his master. He holds his *naginata,* or long spear, in a respectful attitude to the unseen lord, Hideyoshi.

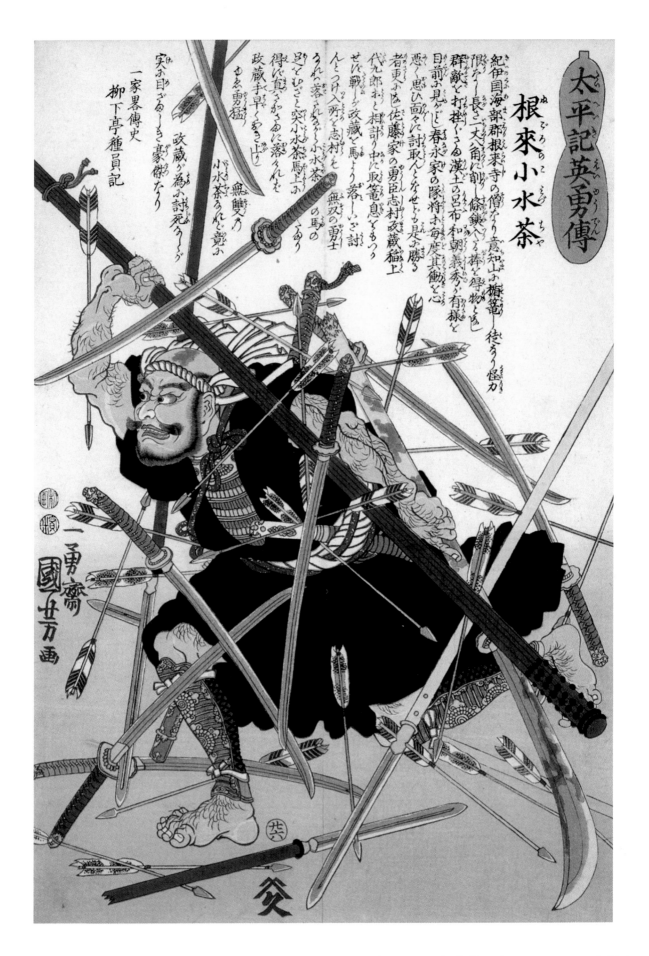

太平記英勇傳

根來小水茶

紀伊国海部郡根來寺の僧なり意和山の椙篭へ一徒うり怪力限なく一長さ一丈八角に削一除へ鑲へる棒を得物とし群敵と打挫くさる漢士の呂布和朝義秀の有様を目前ふ見がじ春永家の隊将お每度其動を悪し思ひ向々に討取んとなせり是ふ勝る者更ふは佐藤家の勇臣志村政蔵稲上代九郎おと相詞り中に取筆息ぞもつせい戦一ツ政蔵を馬よう落いざ討んとつけ入所ふ志村を無双の勇士小水茶小水茶るんど競ふの馬の政蔵が為か討死うさ〜グ実ふ目ざるしき豪傑なり

無双力

一家暑傳史
柳下亭種員記

26. Negoro-no Komizucha. Komizucha was a *sohei*, a warrior-monk, shown here in battle armed not with the samurai's weapons, but instead with just a massive club— even so he seems to be holding his own against a fusillade of spears, swords, and arrows.

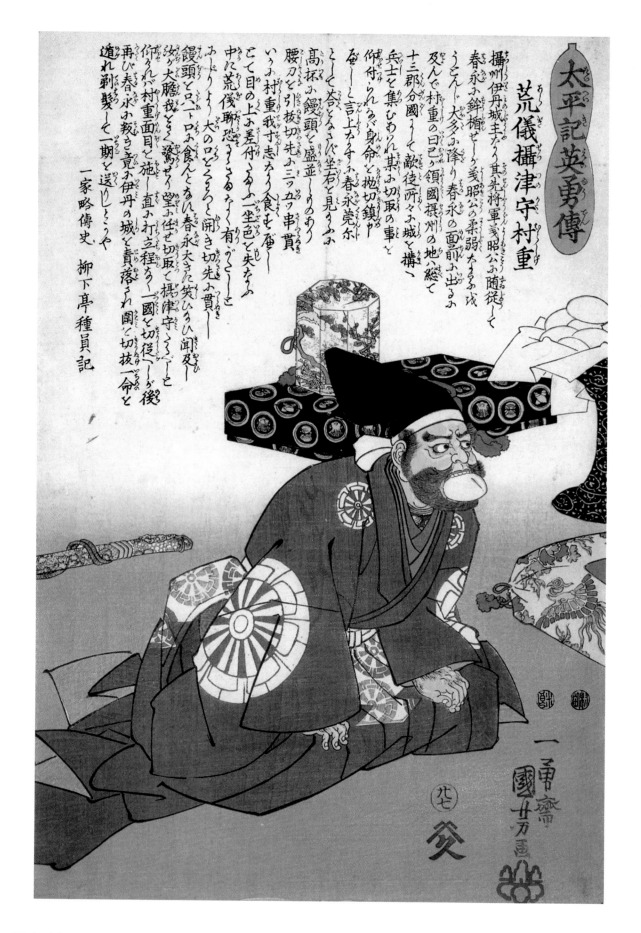

太平記英勇傳

荒儀攝津守村重

攝州伊丹城主たり其先將軍義昭公に隨從して
春永に鉾楯せしか義昭公の柔弱たるを戒
うとんし大多か降り春永方に出るに
及んで村重の日己か領國攝州の地八總て
十三郡分國うて敵後徒所々に城と構へ
兵士を集ひられて敵後に切取の事と
仰付られるか身命を拋切鎮や
と言上せかるさは坐右と見うか
高排か饅頭を盛並べりのあり
腰刀を引抜切先か三ツカッ串貫
いふ村重我寸志を奉こて食を奉
こて目の上か差付するに一坐色を失なひ
中に荒儀聊恐さるなく有へいさ
みたりくり大の口とくろくと開き切先か貫ー
饅頭と口二十口に食んとなん春永大き
女か大膳我をく驚せり望か任せ切取て攝津守うこと後
仰られ村重面目とく施し直か打立程う一國を切従し後
再び春永か救さ竟か伊丹の城と責落され關と切抜一命を
遁れ剃髪して一期と送りしとうや

一家略傳史

柳下亭種員記

27. Araki Settsu-no kami Murashige. This print depicts a powerful warrior, Araki Murashige, wearing ceremonial dress and an official hat and surrounded by the accoutrements of status and authority including the elegant sword-sheath and the lacquer table, but posed in a humble position with a rice cake in his mouth. The text reveals that the warrior has just accepted the cake from the knife of his master as a sign of loyalty and respect.

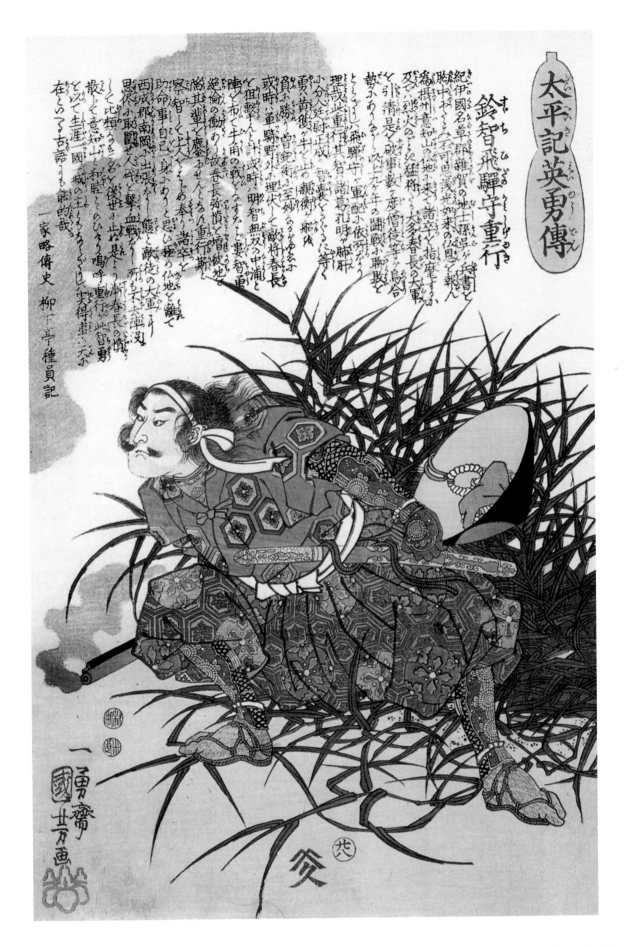

28. Suzuki Shigehide. Samurai Suzuki Shigehide is shown with many of the Japanese warrior's traditional weapons, but also with a smoking firearm in his right hand. The Portuguese brought the first firearms to Japan in 1542, and the first Japanese muskets were being produced there very shortly thereafter.

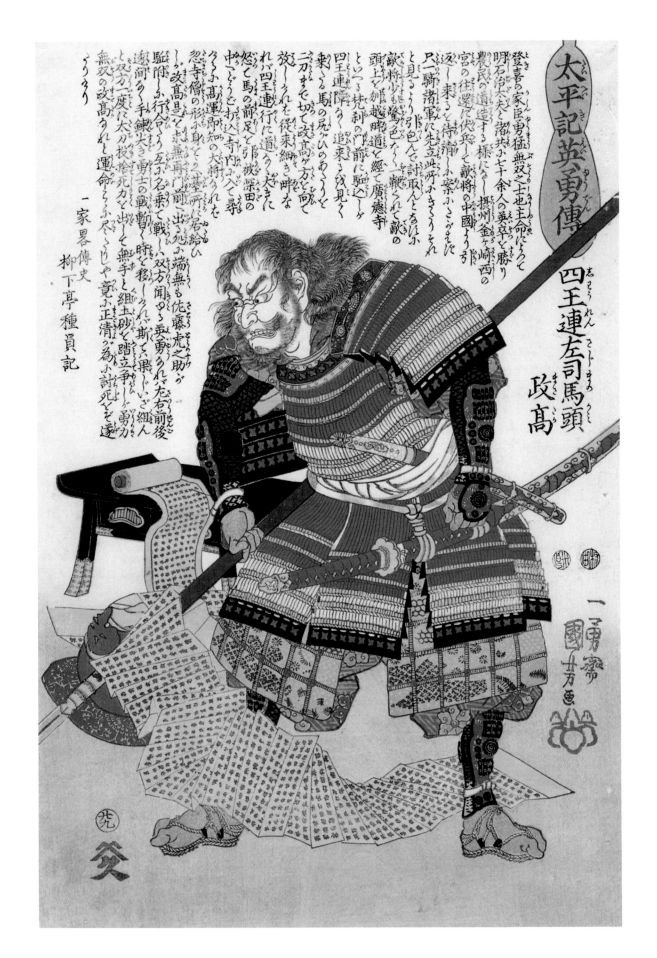

29. Shiōden Tajima-no-kami Masataka. Depicting a famous incident from the battles of this period, Shiōden is searching in a temple for his enemy Hideyoshi, and has encountered there a lengthy sutra scroll, which he engages with his sword.

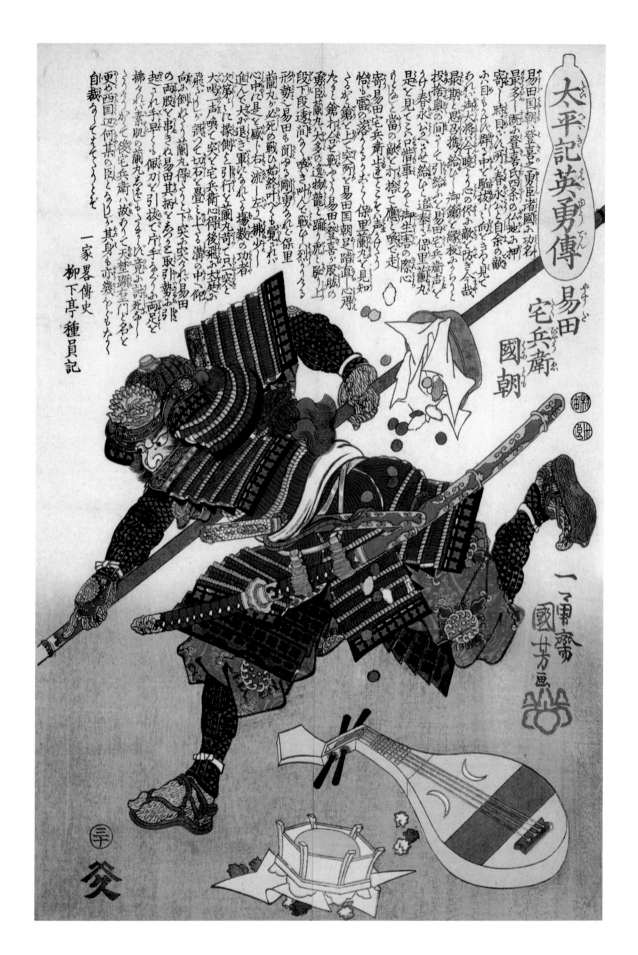

30. Yasuda Sakubee Kunitsugu. Samurai Yasuda Kunitsugu is depicted in a famous attack on his enemy Oda Nobunaga at the temple of Honnoji. Here the warrior proceeds at full throttle across an interior filled with symbolically peaceful objects—the lute on the floor and an overturned box of sweets make it clear that this was not a traditional battlefield.

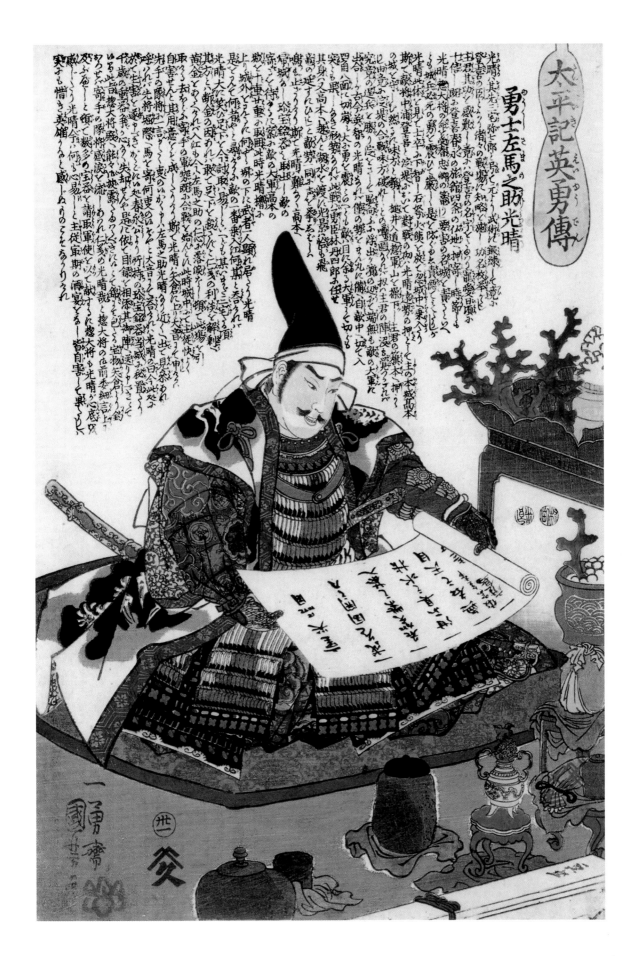

31. Akechi Samanosuke Mitsuharu. Mitsuharu is reading from a scroll listing valuable objects which had belonged to the now-deceased warlord Oda Nobunaga, part of the process of transferring them to those fighting on in Nobunaga's memory.

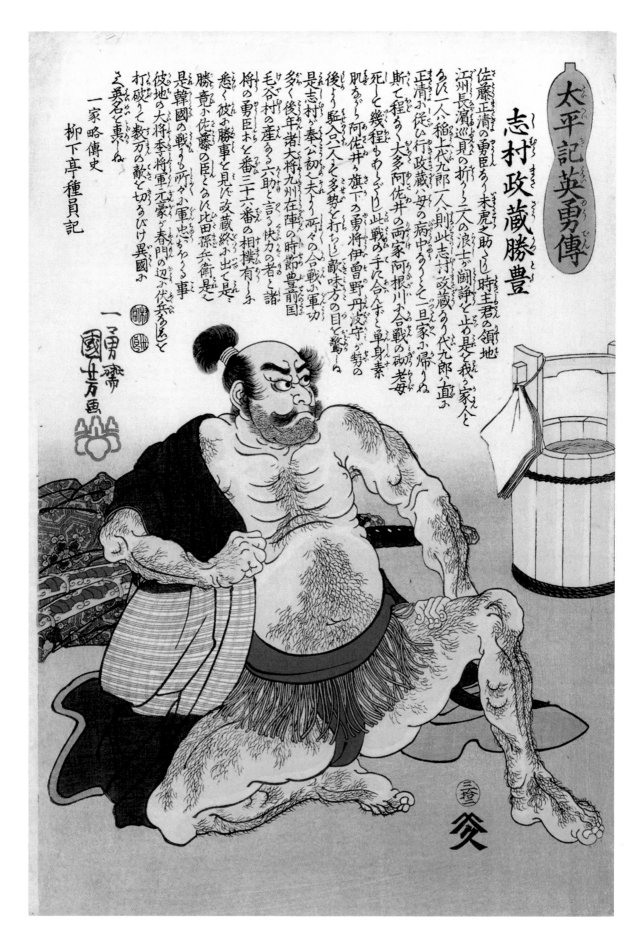

太平記英勇傳

志村政蔵勝豊

佐藤正清の勇臣なり未虎之助といし時主君の領地江州長濱巡見の折から二人の浪士が闘諍を止そ是を我か家臣とし一人は稲上代九郎一人則此志村政蔵なり代九郎か直に正清小従ひ行政蔵八母の病中なりとて一旦家ふ帰りぬ斯て程なく大多阿佐井の両家阿根川す合戦の砌蚊死とて幾程もわつさり此戦の手に合んすと単身素肌ながら阿佐井す旗下の勇将伊曽野丹波守が勢の後ふ駈入六人を多勢と打ちこ敵味方の目そ驚しぬ是志村が奉公の初と天よ所々の合戦小軍功多く後年諸大将九州在陣の時節豊前国毛谷村を番三十六番と言ふ快力の者と諸将の勇臣阿を相撲有ゝ子悉く彼す勝事を見て政蔵終小出て之勝竟小佐藤す臣となるに比田孫兵衛是ゝ是八韓國の戦も所々小軍功彼地の大将李元豪が春門の辺ふ代兵をして打破りて数万の敵を片刃と切るびけ異國ふ之勇名と裏ハぬ

一家略傳史
柳下亭種員記

國芳画
一勇齋

32. Kimura Matazō Shigekatsu. The samurai Kimura is portrayed here as a sumo wrestler. The source of this image was a legendary incident when the warrior, in a military encampment, had defeated an actual sumo wrestler who was widely considered invincible.

太平記英勇傳

濱地將監滿國

一家略傳史
柳下亭種員記

33. Yamaji Shōgen Masakuni. A powerful warrior, Yamaji Shōgen brandishes his long sword in a fierce battle with an unseen opponent. The presence of blooming azalea branches in this composition was intended by Kuniyoshi, according to a traditional symbolism, to indicate subtly that this was the great samurai's last fight.

34. Akashi Gidayū Tadamasu. Akashi has attempted to disguise his samurai's armor and weaponry with a peasant's hat and a coat of straw, but the huge sharpened hoe, very different from any hoe an actual peasant might use, looks just as lethal as any weapon the samurai might ordinarily carry. The iris flower at the bottom is a traditional symbol of manhood.

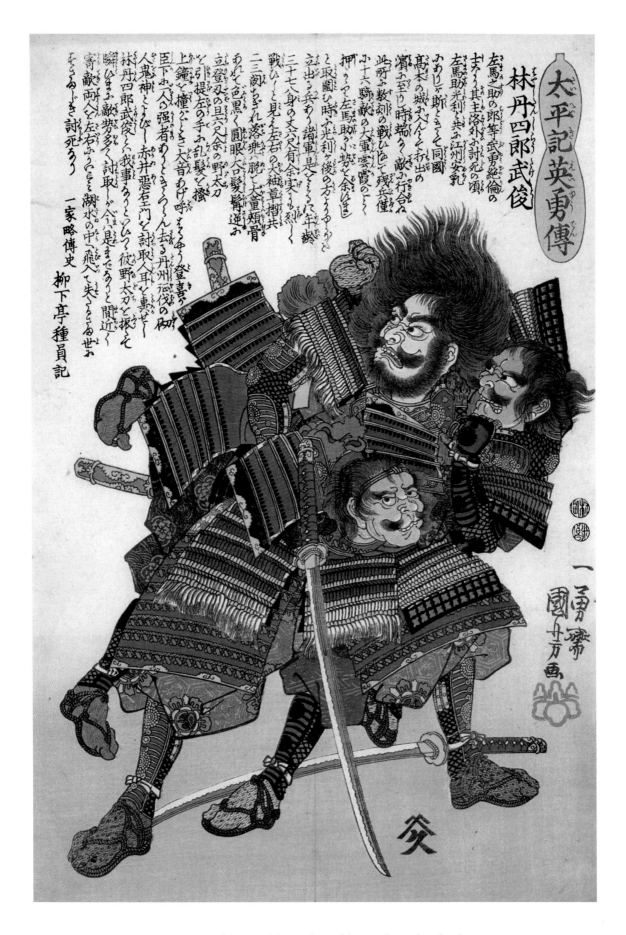

35. Hayashi Hanshirō Taketoshi. In a legendary battle, samurai Hayashi Hanshirō is shown carrying two fully armed opponents off the battlefield, squeezing them so violently that they are turning gray from suffocation.

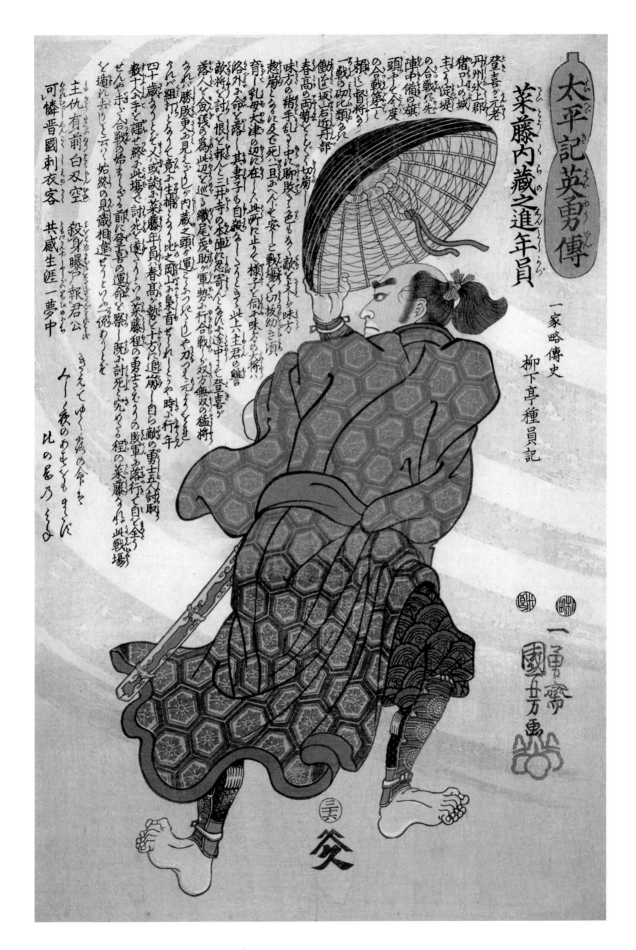

36. Saitō Kuranosuke Toshimitsu. There were circumstances when flight was a reasonable course of action. Here the barefoot Saitō Kuranosuke hides his face with a peasant's hat to try to avoid recognition by his pursuers—in this case, the deception was not successful.

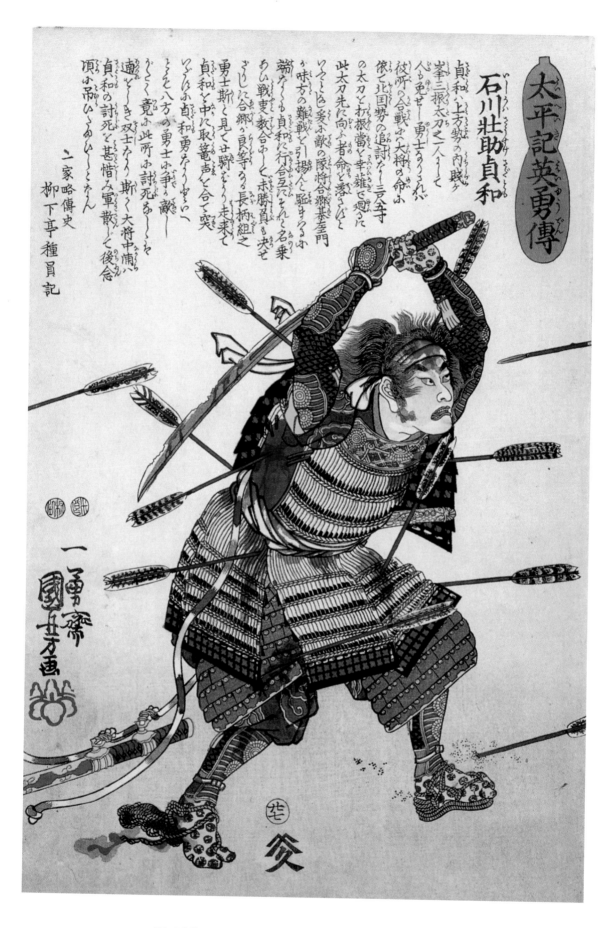

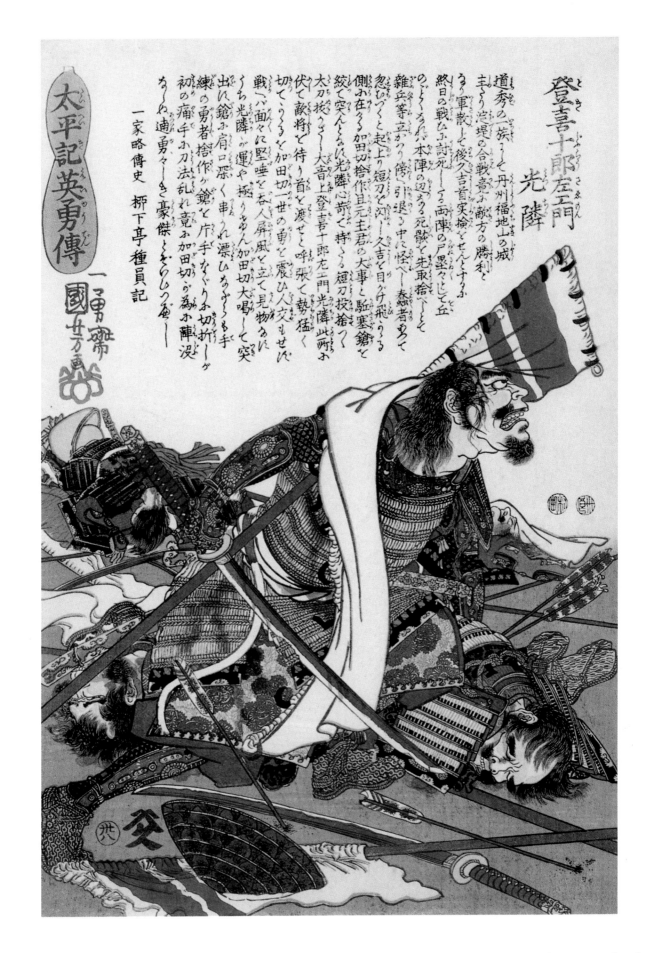

太平記英勇傳

一勇齋 國芳画

一家略傳史 柳下亭種員記

登喜十郎左ヱ門 光隣

道秀の一族にて丹州福地山の城
主たり淀堤の合戦章ふ敵方の勝利と
うち軍散して後久吉首実捻をせんとすふ
のとくろん本陣の辺ろ死隊して両陣の戸墨々として丘
終日の戦ふ討死して両陣の戸墨々として丘
雜兵等立かり傍に引退ふ中に怪べー恭者あて
忽むぐつと起上り短刀で沙に久吉を目がけ飛ふつる
側ふ在る加田切捨作且元主君の大事と駈塞鎗を
絞て突んふに光隣心荷て持くろ短刀投捨つ
太刀抜くて一大音上登喜十郎左ヱ門光隣此所ふ
伏て敵将で待り首と渡さと呼張て勢猛く
切てうつるを加田切一世の勇と加田切大喝して突
戦ふ面々に堅唾を呑ん加田切大喝して突
出ふ鎗ふ肩口深く串れ漂ひ力づくも手
練の勇者捨作ケ鎗と片手なぐりふ切折して
ち光隣ふ運や極りしん加田切ふ為ふ蔭涙
初の痛手ふ刀法乱れ竟ふ加田切ふ為ふ蔭涙
ちへぬ通ふ勇々しき豪傑とぞらひつ畾

38. Akechi Jūrōzaemon Mitsuchika. This is the only print in this set in which Kuniyoshi depicted a battlefield following a furious fight. In one version of this narrative, Akechi Mitsuchika, the samurai shown here, camouflaged himself among the many corpses to have a chance to spring up and attack his major enemy.

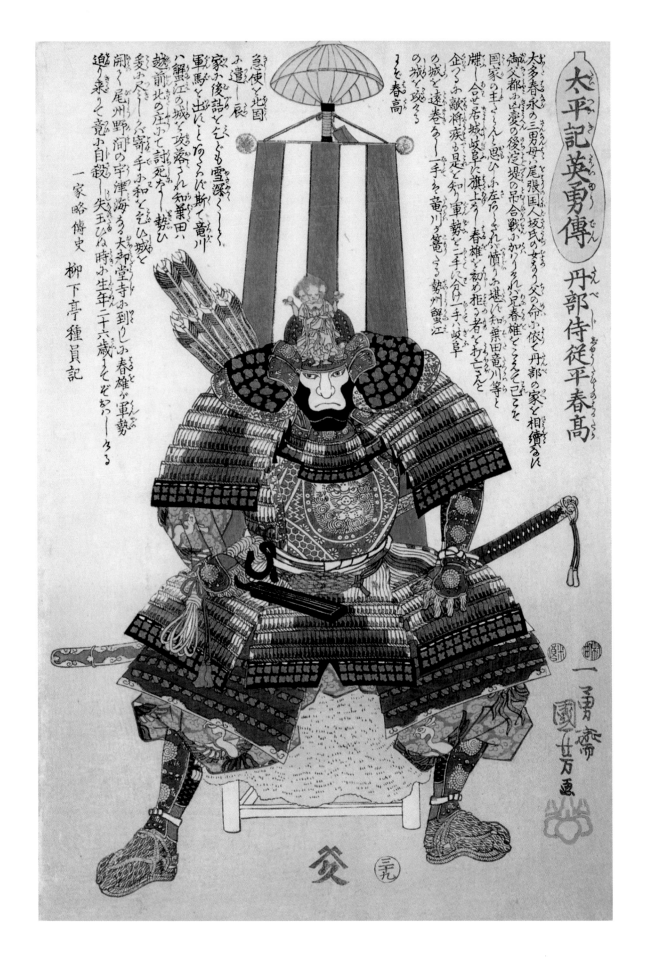

太平記英勇傳

丹部侍従平春高

大多春永の三男母ハ尾張国人坂氏の女うハ父の命に依り丹部の家を相續するに国家の主なると思ひ左右されお堪に知る春雄ととそれに兄春雄ととそれに知る名城に岐阜に旗上う春雄を初め拒む者を打亡し企つる歌将疾を足と知り軍勢を二手に合け一手ハ岐阜の城を遠巻る一手を竜川が篭る勢州蟹江をそ春高

急使を北国み遣し一辰家か後詰を乞むとも雪深く軍馬を出しとそろに斬て竜川八蟹江の城を攻落され知兼田越前北の庄ふて討死なり勢ひ叢ハり城と乞ひ城と叢か尾州野間の宇津海る大御堂寺か到りしふ春雄が軍勢追ひ乗りて竟ふ自殺一失玉ひぬ時か生年二十六歳をそぞおハーる

一家略傳史
柳下亭種員記

39. Oda Nobutaka. The samurai is sitting on a campstool covered with a fur rug. Behind him is his personal banner with a *karakasa*, a Chinese umbrella, attached at the top.

As part of his armor, the seated samurai is wearing a *hoate*, a protective facemask that covers his cheeks and chin.

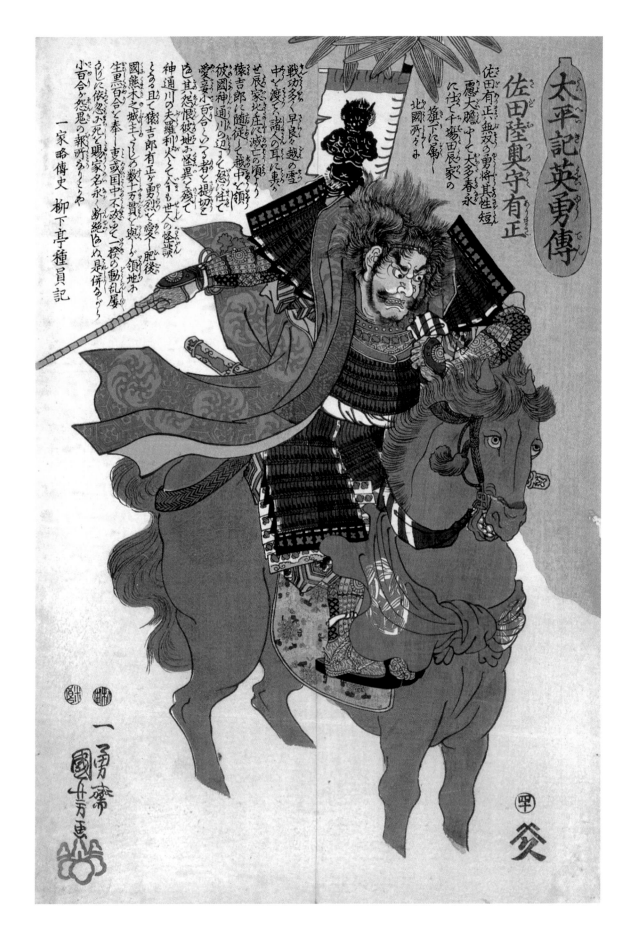

40. Sassa Narimasa. A dramatic scene portrays the samurai on horseback on the side of a mountain in a winter storm. The horse's legs disappearing in the snow and the warrior's wild hair and waving garments confirm the ferocity of the weather.

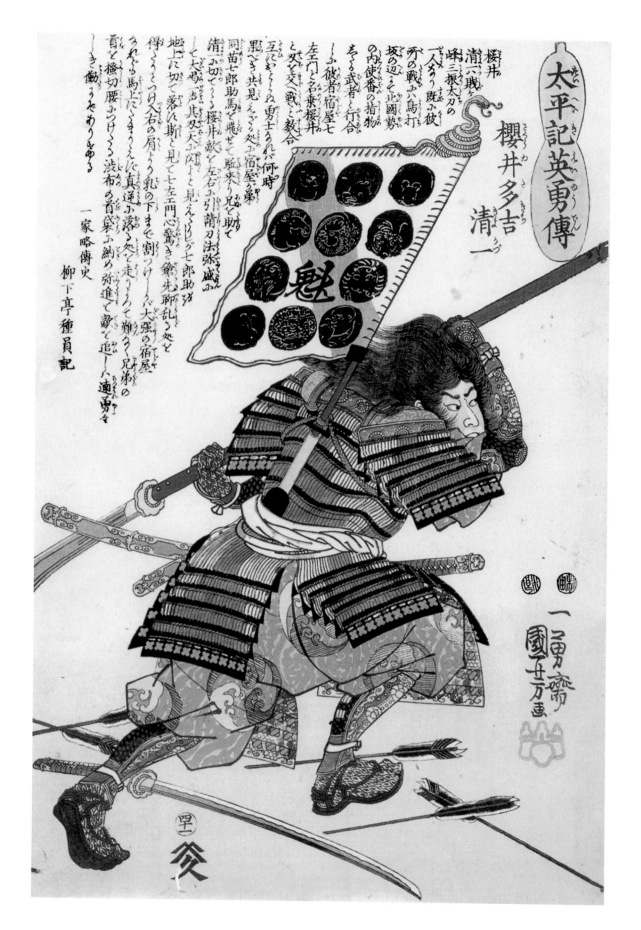

41. Sakurai Sakichi Iekazu. The samurai, in full spear attack, is oblivious to the arrows at his feet. His *sashimono*, or personal standard, displays eleven of the twelve zodiac animals. The snake, rendered instead in gold at the top of the standard, has been replaced in the middle of the second row from the bottom by the character which means "charging ahead of others."

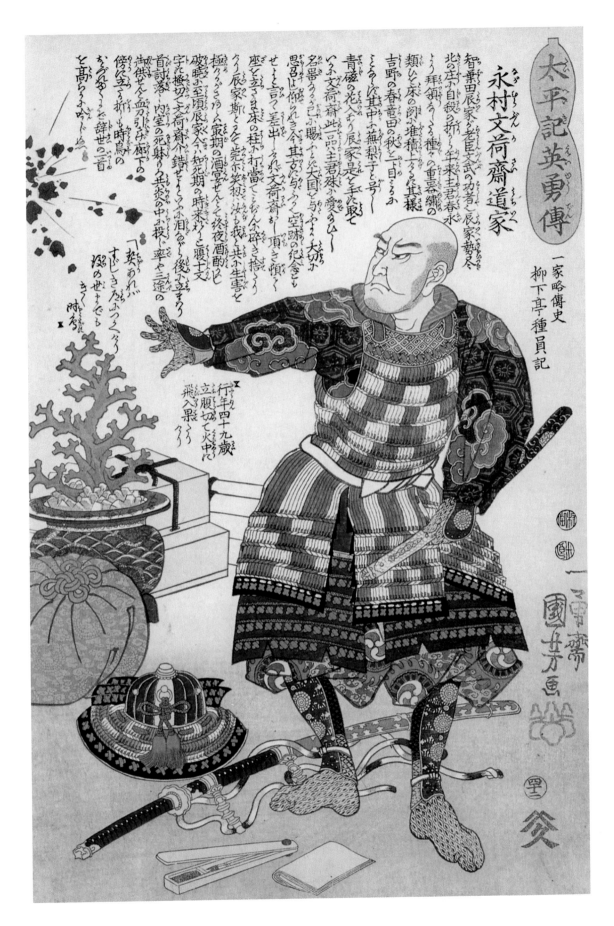

42. Nakamura Bunkasai. With fortune no longer on his side, Nakamura Bunkasai, his face a mask of resolution, prepares to end his life by committing *seppuku*. Fragments of a vase, a gift from his lord, are shown at the upper left—the samurai declared his intention not to live after his lord's death by destroying this valued present. At his feet are the brush case and paper he will use to compose a farewell poem before taking his life.

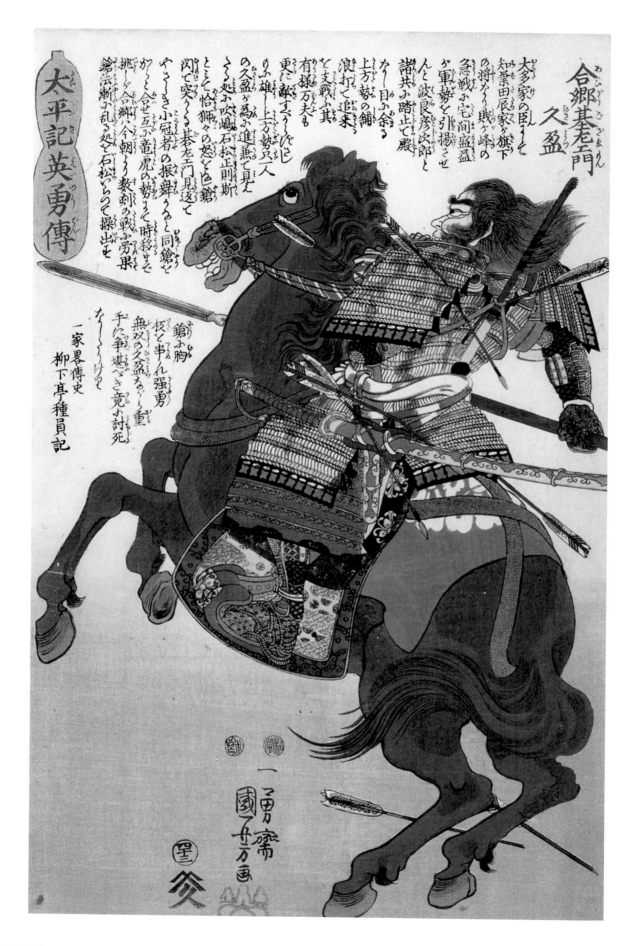

43. Haigō Gozaemon Hisamitsu. This is one of the two prints in this series in which Kuniyoshi depicted a samurai on horseback. Wounded and spattered with blood, his standard destroyed, the samurai aims his spear at the unseen enemy and urges his horse on, away from the viewer.

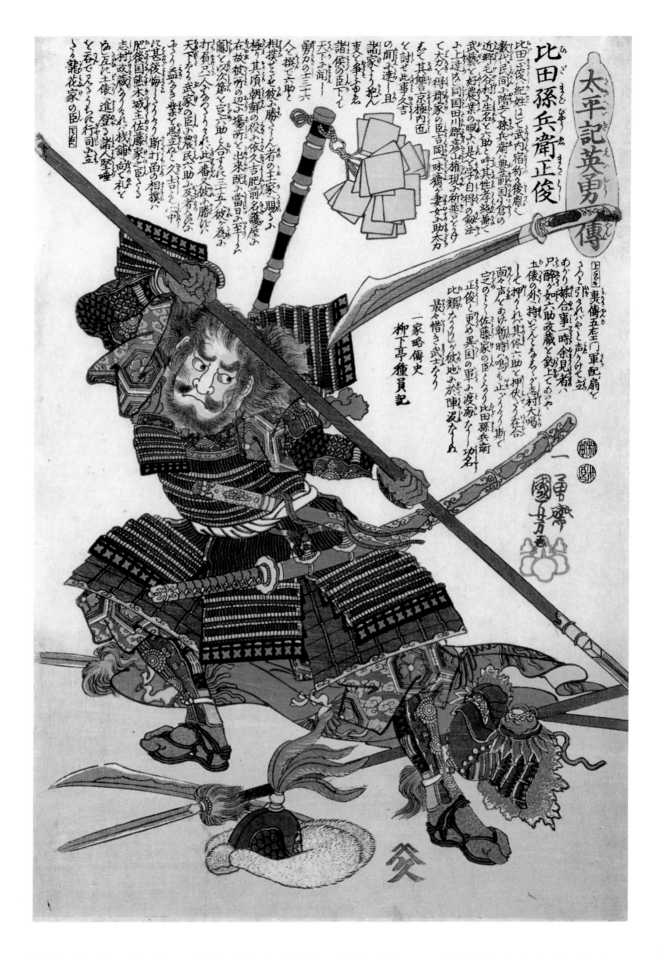

44. Kida Magobee Muneharu. Kuniyoshi depicted Kida Magobee fighting in this print with weapons, both the sword on the ground and the one in the air, of Manchurian design. This samurai died in battle in the Manchurian area of Orangai, north of Korea.

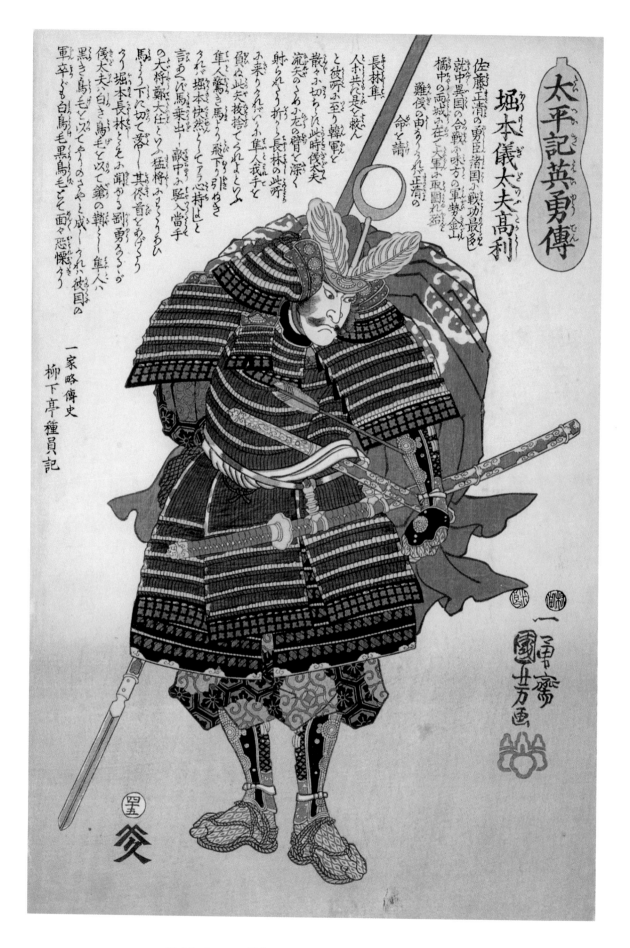

太平記英勇傳

堀本儀太夫高利

佐藤正清の勇臣諸国ふ戦功最も
就中呉国の合戦ふ味方の軍勢金山
橘中の両城の在て大軍ふ取圖れ給
難俊の由ろうふれ正清の
命を請

長林隼
人其共是と敘ん
と彼所ふ至り韓軍と
散らふ切らちれ此時儀太夫
流矢のくらふ老の臂を深く
射られうり折り長林の此所
ふ来りうれぐいと飛下り引ぬき
熊ね此矢抜捨てられよとふ
隼人驚き馬とう飛下り
れば堀本快然くくてアラ心将
の大将轄大壮とふ猛将ふくくうらふい
言あくふ馬乗出し献ふ首とめぐくう
り堀本長林ミミふ聞かる副勇ろろくつ
馬く下く切て落ち 其俊首とめぐくう
儀太夫ハ白き烏毛と以て鎗の鞘く隼人ハ
黒き烏毛とミつてやうのさやくぶき
軍卒ぐも白烏毛黒烏毛ミぞ面々恐慌うろ

一家略傳史
柳下亭種員記

45. Morimoto Gidayū Hidetora. The fully armed warrior
gazes with stoic curiosity, but displays no sense of urgency, at
the enemy arrow which has pierced his left arm.

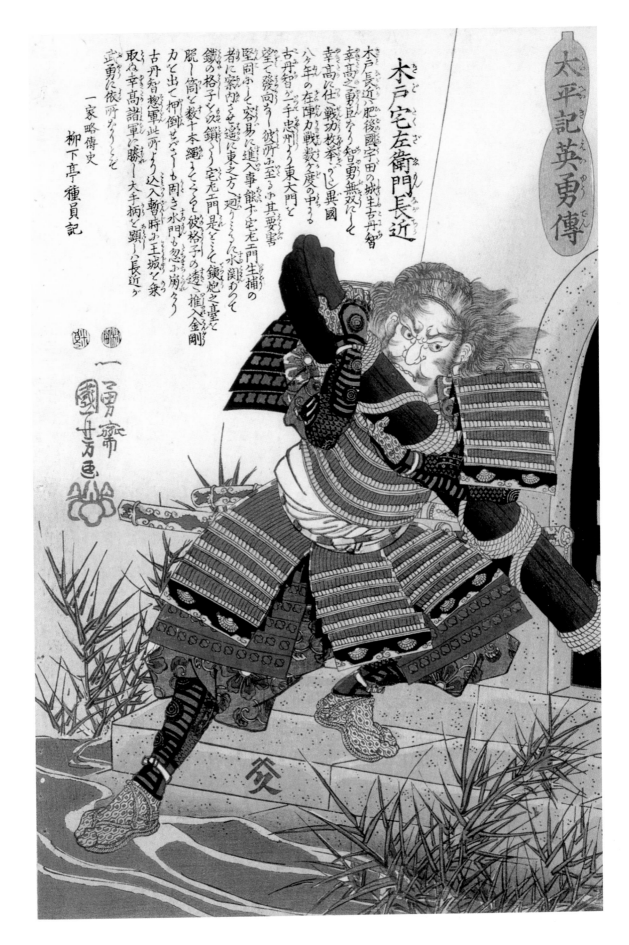

46. Kido Sakuzaemon Norishige. The powerful samurai
attacks the iron gates of a man-made waterway with a heavy
piece of improvised equipment, a massive wooden sledge.

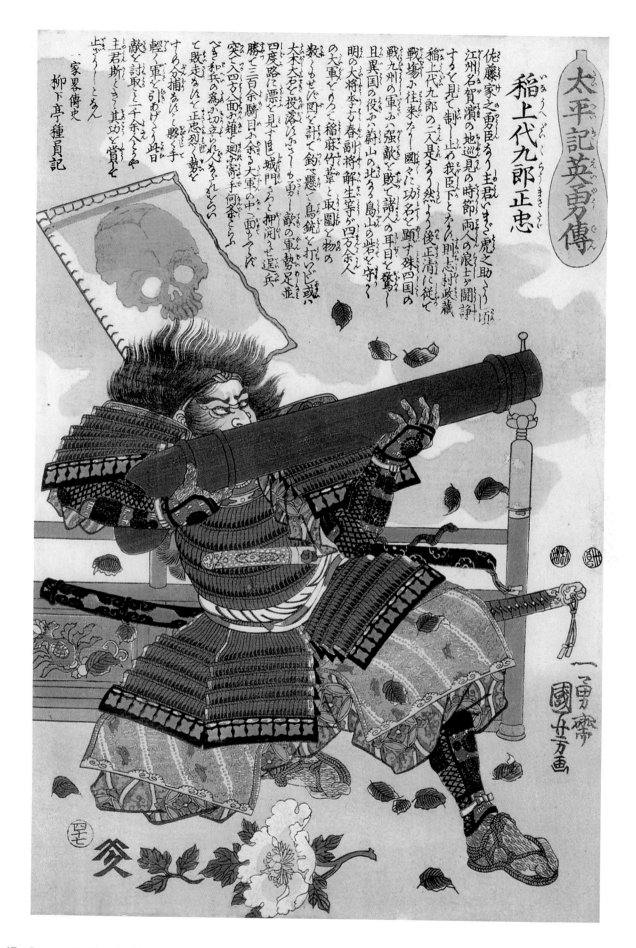

太平記英勇傳

稲上代九郎正忠

佐藤家之勇臣らう主君いまだ虎之助らう頃江州名賀濱の地巡見の時節両人の浪士が闘諍するを見て制止らう我臣下となん即ち志村歳蔵稲上代九郎の二人是らう然らう後正清に従て戦場ふ往来なり國に功名を顕す殊四國の戦九州の軍ふ強敵を敗て諸人の耳目を驚し且異國の役ふ蔚山の北らう島山の砦を守る明の大将李より春副将解生芋が四万余人の大軍をりて稲麻竹葦と取圍と物の数ふせいに圖て釣べ懸い鳥銃を拈びど或は太木太戸と投落ふさ一も勇一敵の軍勢足並四度一路ふ見す目城門らう余る大軍の中ふ面すべ突入四方へ雖れ追尋手何家らう勝一和兵を引わげらう此日すら分捕とし敷く手軽く軍を引わげらう主君斯と云其功を賞て止らうーとん

一勇齋
國芳画

家累傳史
柳下亭種員記

47. Inoue Daikurō Nagayoshi. Inoue Daikurō is shown firing an improbably large hand-held cannon, possibly in battle with Chinese troops. The peony, a tra-ditional symbol of affluence in China, here lies on the ground at the feet of the Japanese warrior.

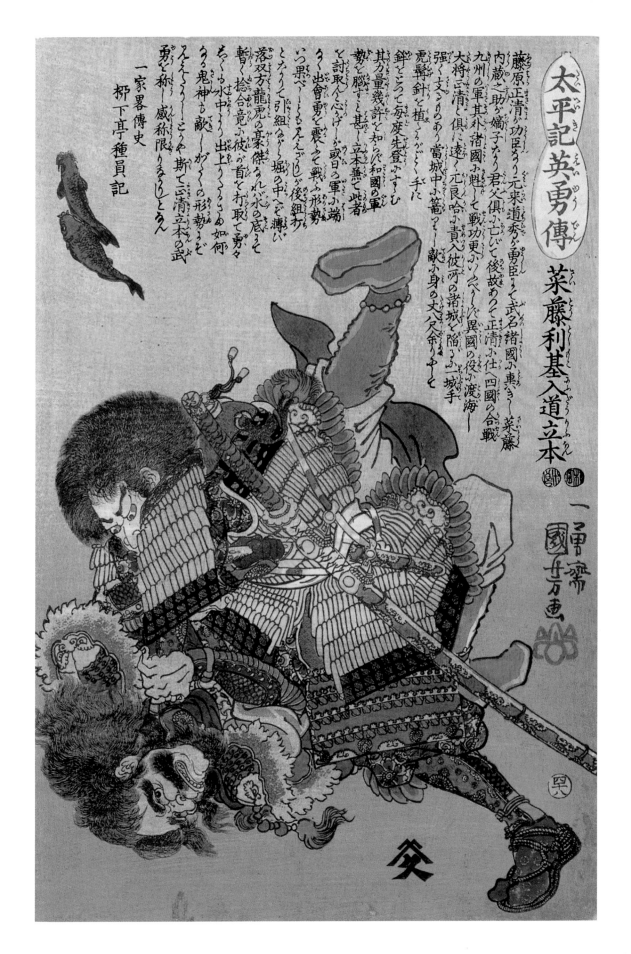

太平記英勇傳

菜藤利基入道立本

一勇齋國芳画

藤原正清が功臣うり元来道秀が勇臣て武名諸國に轟き、菜藤内蔵之助が嫡子なり君父倶に諸國に赴て戰功更かうべし異國の役に渡海九州の軍其外諸國へ戦功ありて正清が仕て四國の合戰大将正清と倶に遠く亡良哈が責入彼阿の諸城に陥ふ一城手強く支ふるのあう當城中小篙に敵小身の大尺余りとて兜弯針と植ころぐどい手に針とそって毎度先登みすむ其力量幾許と知らい和國の軍勢と腦すと甚立本善で此者と討取んと心うげーぶ或目の軍小小端う出會勇と震へて戦ふ形勢とたうて引組みが後組むいつ果べーよんえぐりしが堀の中へ薄い落双方龍虎の豪傑すれが水の底うそ暫と捻合竟ふ彼が首を打取て勇々ちくう水中うううめ如何うう鬼神も敵ーがくの形勢うぞえるううところや斯て正清立本の武勇と称し感称限りぬるりとえ

一家畧傳史
柳下亭種員記

48. Saitō Toshimitsu nyūdō Ryūhon. The two fish swimming upward in the overall gray-blue background identify this as a scene of underwater hand-to-hand combat between the Japanese samurai with his traditional equipment and his Manchurian opponent.

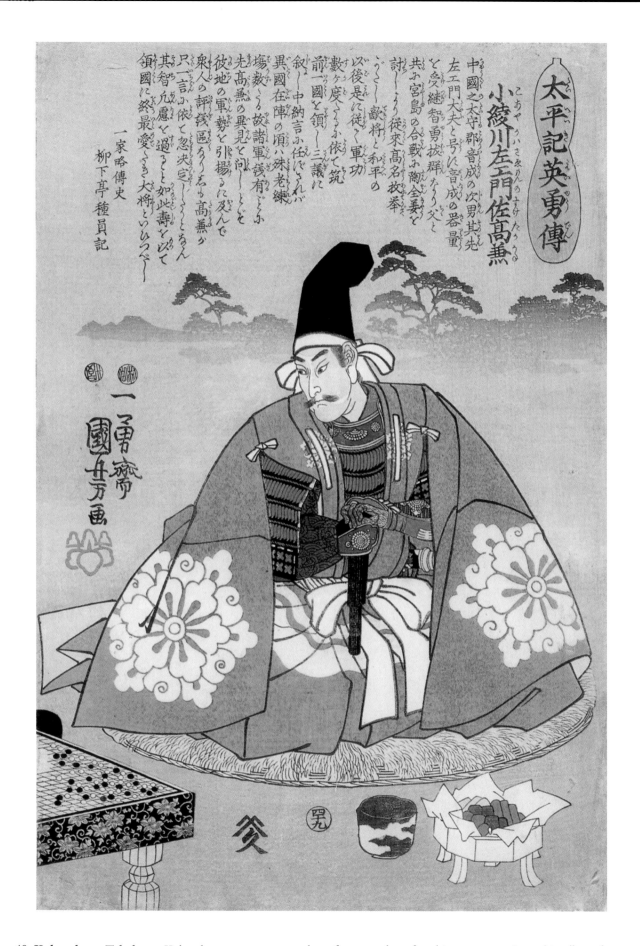

49. Kobayakawa Takakage. Kobayakawa was as renowned for his intelligence and wisdom as governor of his people as for his prowess as a warrior. Here he wears his official cloak over his samurai's armor, and the items in front of him in the foreground confirm his status as a wise and intellectual man committed to peace in the area he ruled—the box of sweets, the cup for the tea ceremony, and the *go* board at which he stares, contemplating his next move.

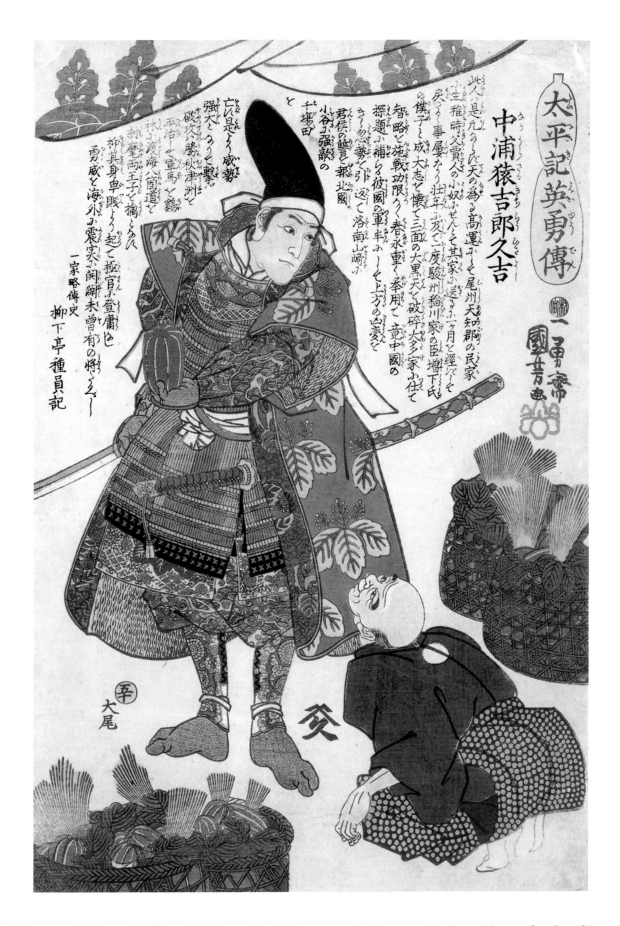

太平記英勇傳

中浦猿吉郎久吉

一勇齋
國芳画

此人は元より天の為る高運ふ古尾州天知郡の民家ふ
生稚時ふ賣父の小奴ふせんと其家ふ送ふ一ヶ月を經ラシテ
戻ラて事屬ちう壯年ふ及て一度駿州稲川家の臣増下氏
ら僕子と成大志を懷て三面の大黒天と奉用て破碎ふ多家ふ仕て
智略と施戰功限ふ春永重く奉用て竟中國の
探題ふ補ら彼國の軍半ふ一と上方の凶徒と
さう忽勢を引て遂ふ洛南山崎小
君侯の鬱を報北國
小谷り強敵の
千塚田

と

亡にふ是よう威勢
強大ラリと撃ち
破欠藝秋津州
平治シて宣馬ム鷄
訣庵両王子ル鶏
林小渡海八筒道と
抑其身卑賤よう起て極官ふ登庸ふ
勇威を海外ふ震實ふ闢末曾有の將そぐ〜

一家略傳史
柳下亭種員記

辛
大尾

50. Toyotomi Hideyoshi. Hideyoshi holds a melon in his left hand, a gift to the samurai's troops from the farmer kneeling at his feet. As he distributed the gift of melons to his troops, Hideyoshi contrasted the loyalty of the peasant with the treacherousness of some of his more powerful enemies. The samurai's robe and the tent flap above him are decorated with a paulownia crest. The artist Kuniyoshi also used the paulownia image in his artist's seal seen here on the right in red below his signature.

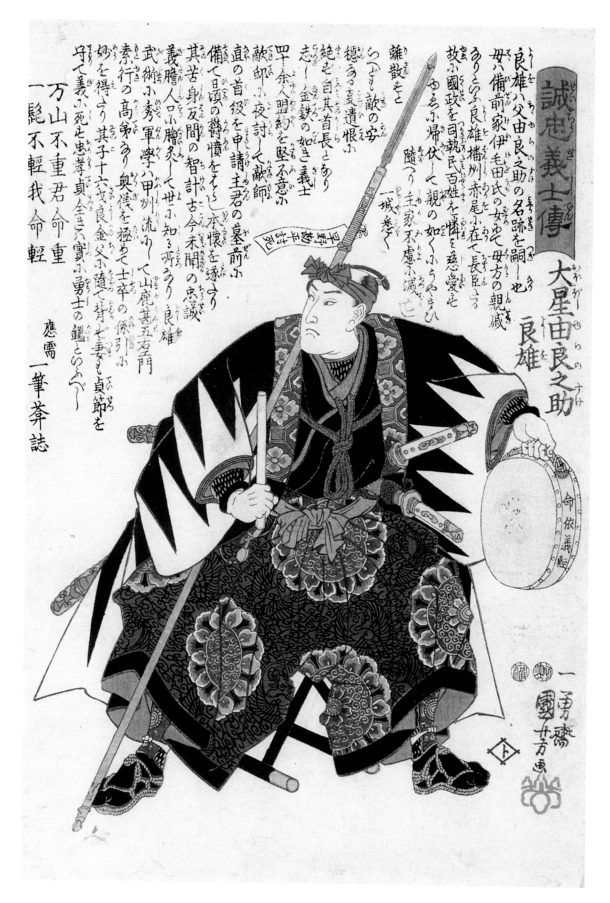

誠忠義士傳

大星由良之助

良雄

万山不重君命重
一髪不軽我命軽

應需一筆菴誌

51. Ōboshi Yuranosuke Yoshio. The samurai is seated on a campstool, beating a drum. Ōboshi, leader of the attack on December 14, 1702, gave the signal to proceed to his troops with such a drum, and used it to direct the 47 rōnin in their successful battle that night. (The full name of the enemy of the 47 rōnin was Kōno Musashi no Kami Moronao. For the sake of simplicity, the attack on his mansion is often referred to in these captions as "the Kōno attack").

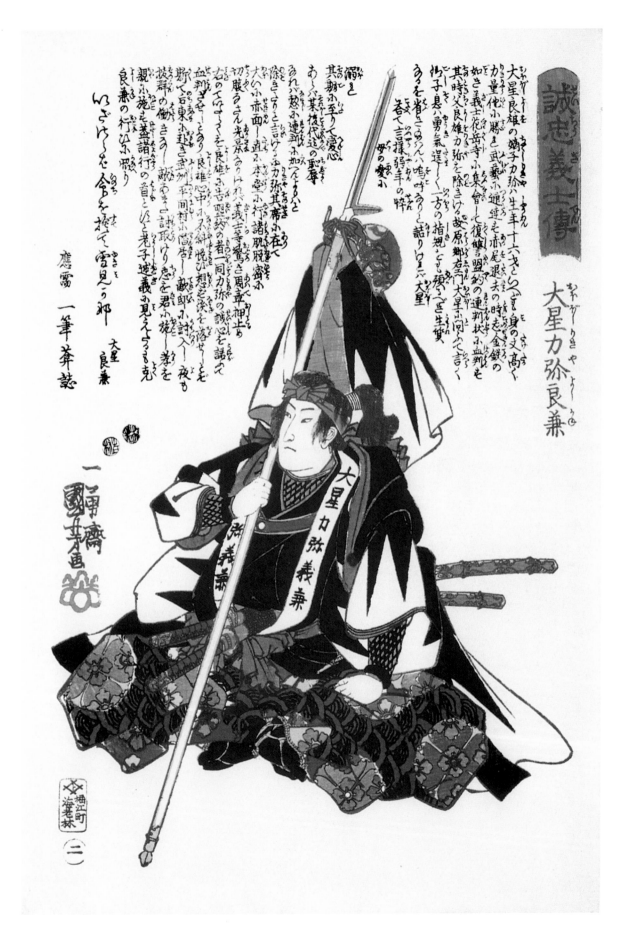

52. Ōboshi Rikiya Yoshikane. A young samurai, Ōboshi Rikiya, is seated with his spear, to which are attached his helmet and cape.

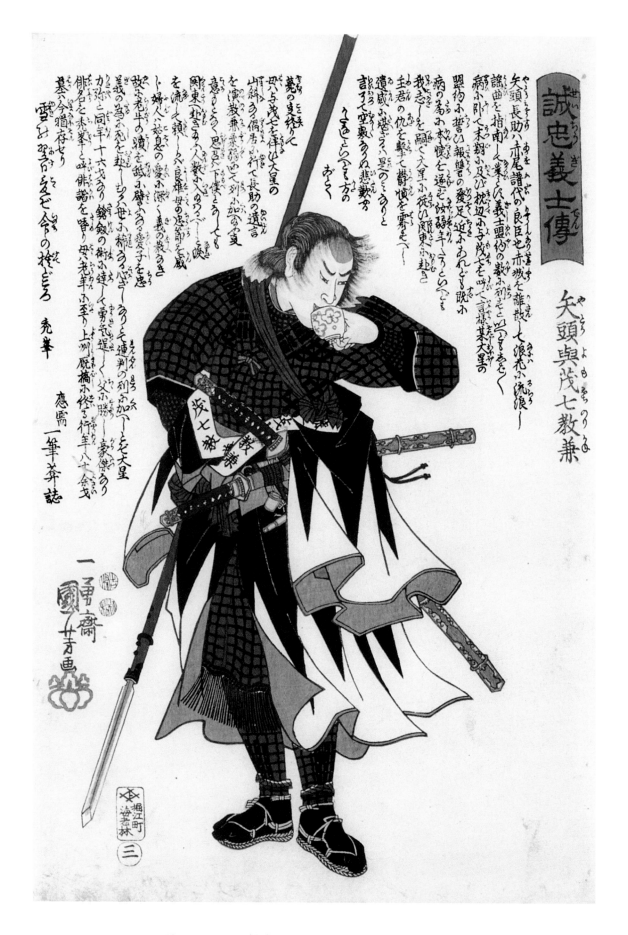

53. Yatō Yomoshichi Norikane. Drinking from a decorated cup, samurai Yatō Yomoshichi is prepared for battle with the samurai's standard weaponry, the two swords and the spear.

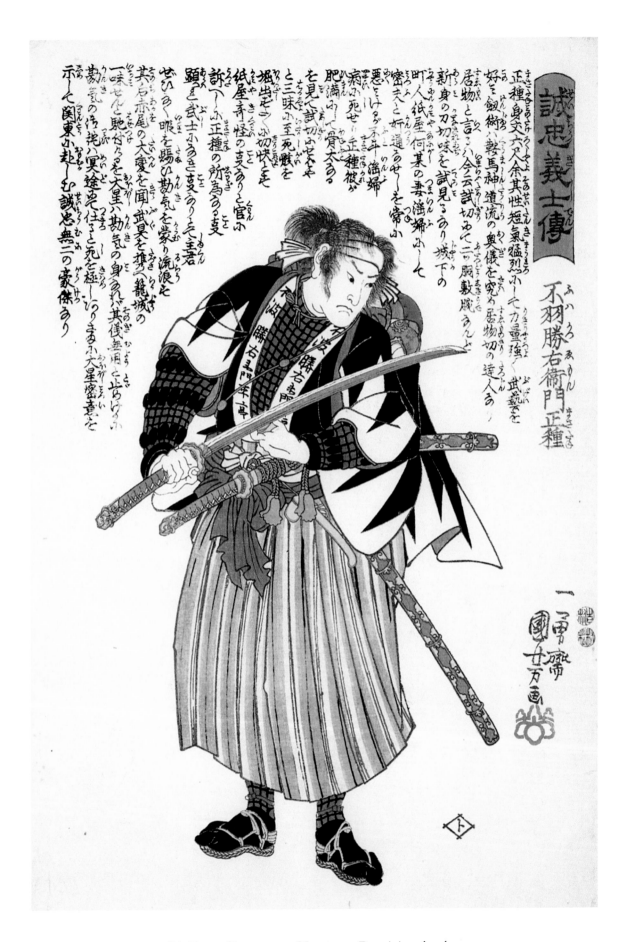

54. Fuwa Katsuemon Masatane. Examining the sharp edge of his longer sword, the samurai is wearing the same dog-tooth pattern cape worn by most of the warriors pictured in this series of prints.

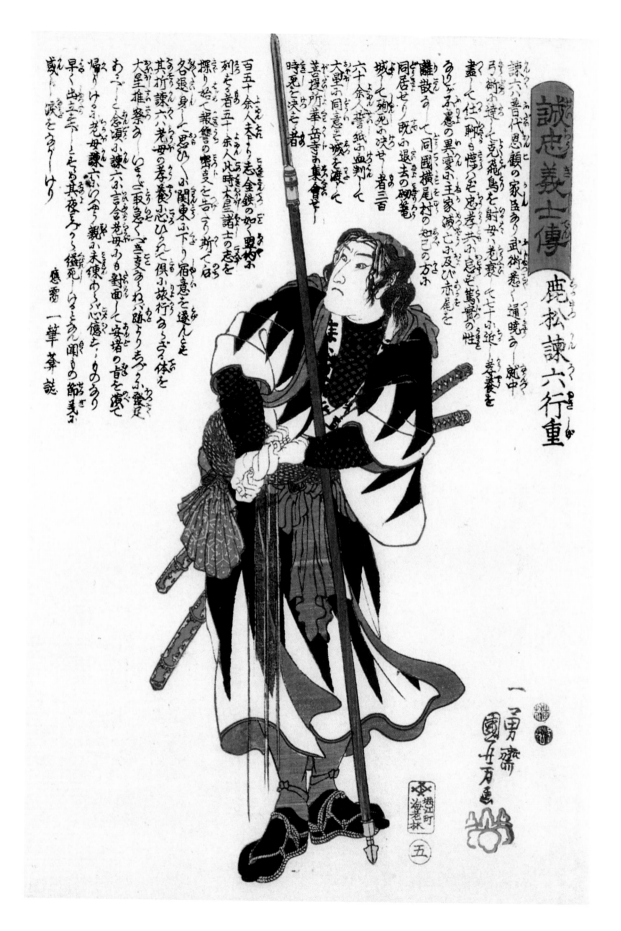

誠忠義士傳

鹿松諫六行重

諫六は普代忍頭の家臣あり武術に通暁の一就中弓術お達せり克飛鳥を射母は老衰して七十に近し老養を盡して仕ありときく忠孝共の息を篤實の性ありしが子慮の異愛み主家滅亡に及び赤尾を離散せり同居せり國横尾村の如この方ふ菩提所華岳寺の集會せて城に殉死の決せ者三百六十余人誓に紙に血判して時兆を決せ る者百五十余人夫より志金鐵の如き列そる音五十余人此時大星諸士の志を探り始て報讐の密意を告り斷て名退身ひと思ひ水關東ふ下り宿意を遂んとて其折諫六老母の孝養忠ひられて倶に旅行ありさふ大星推察のいまさ取急く さ變えふねよふふ登足あらこと念頃み諫六言合老母ふも對面して安堵の旨を遣て歸りけるに念ふ老母心ふも未練のふ助より志々ふ早く出立とゝそれ其夜とゝ纖死けるとん聞の節義を或ふ出立とゝそれ其夜とゝ纖死けるとん聞の節義を涙をそゝぎ一り

應需 一華芳談

55. Shikamatsu Kanroku Yukishige. Before the attack on December 14, 1702, the aged mother of this warrior committed suicide so he would not be dissuaded from doing his military duty because of his concern for her well-being. Kanroku is shown here with a sad expression, wringing water—which stands symbolically for his tears for his mother—from his sleeve.

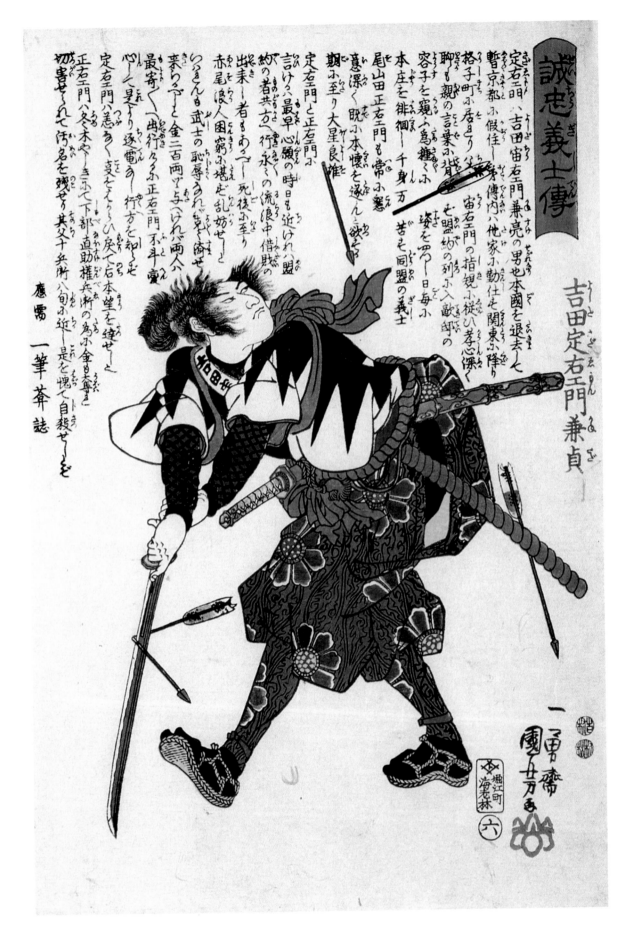

56. Yoshida Sadaemon Kanesada. A theme often revisited in samurai prints, the warrior is fending off arrows with his sword.

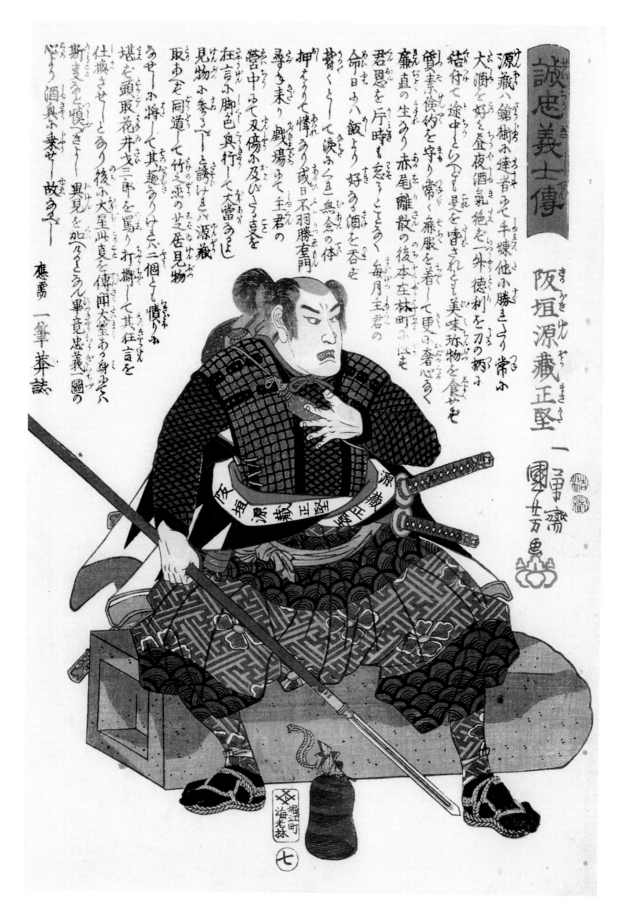

57. Sakagaki Genzō Masakata. Genzō was known to enjoy his sake more than most of his comrades. Here he is sitting with his sake pitcher on the ground in front of him, serving as a canteen.

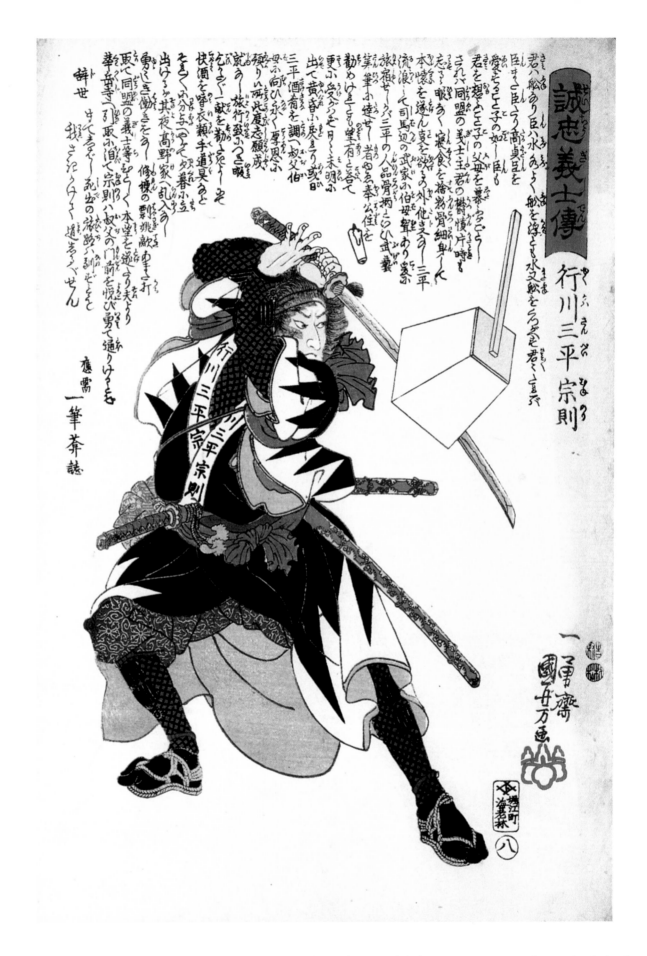

58. Yukukawa Sampei Munenori. The famous attack of 1702, the subject of this series of prints, was an attack on a mansion and many of the prints show domestic details, often in a slyly humorous way. Here the warrior in battle has encountered a lantern which he dispatches with his sword.

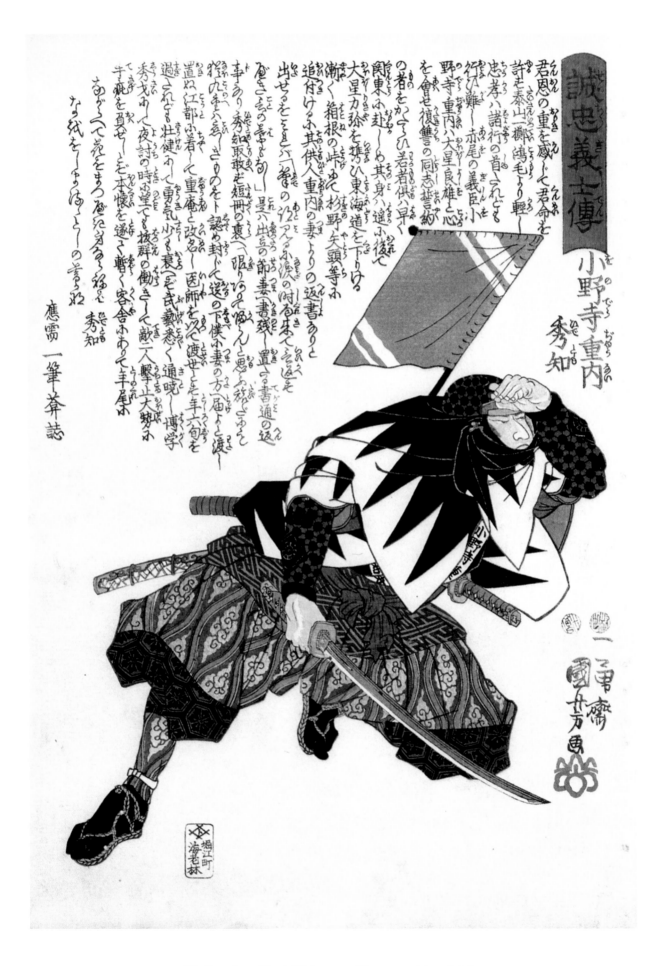

59. Onodera Jūnai Hidetomo. The samurai in a fighting
position resting on one knee, shading his eyes.

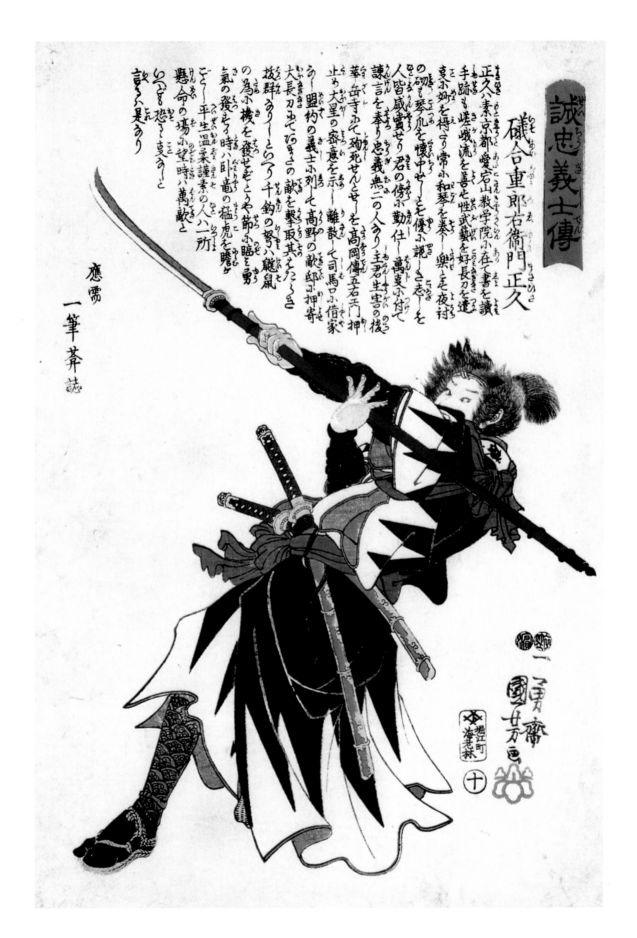

60. Isoai Jūroemon Masahisa. This warrior was famous for being particularly adept with the *naginata*, the glaive or spear which the samurai carried along with their swords. He used it to kill many enemy warriors on the night of the Kōno attack.

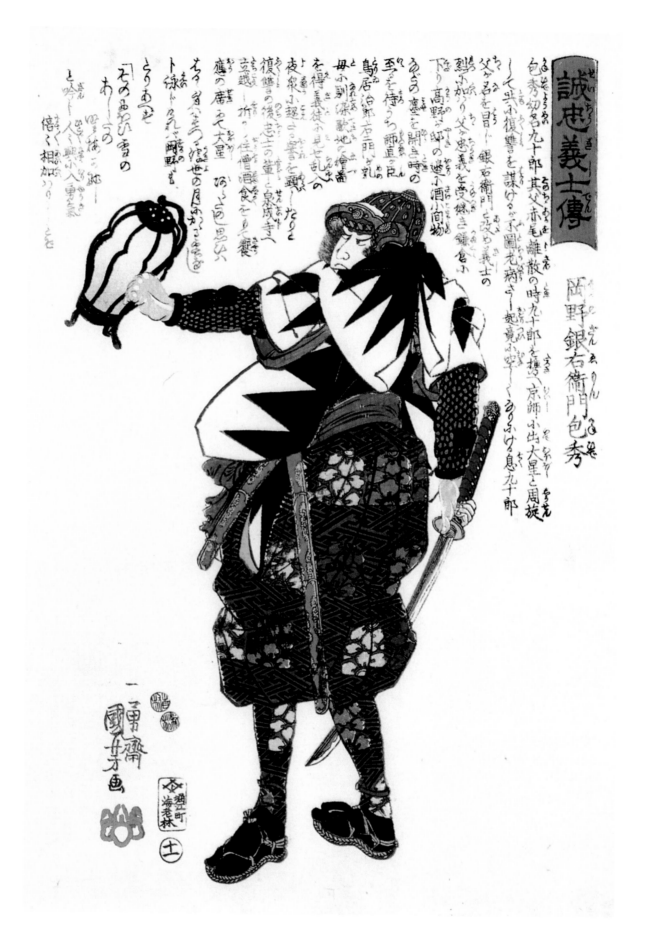

61. Okano Gin-emon Kanehide. One of the youngest samurai who took part in the Kōno attack, Okano is shown here holding a lantern.

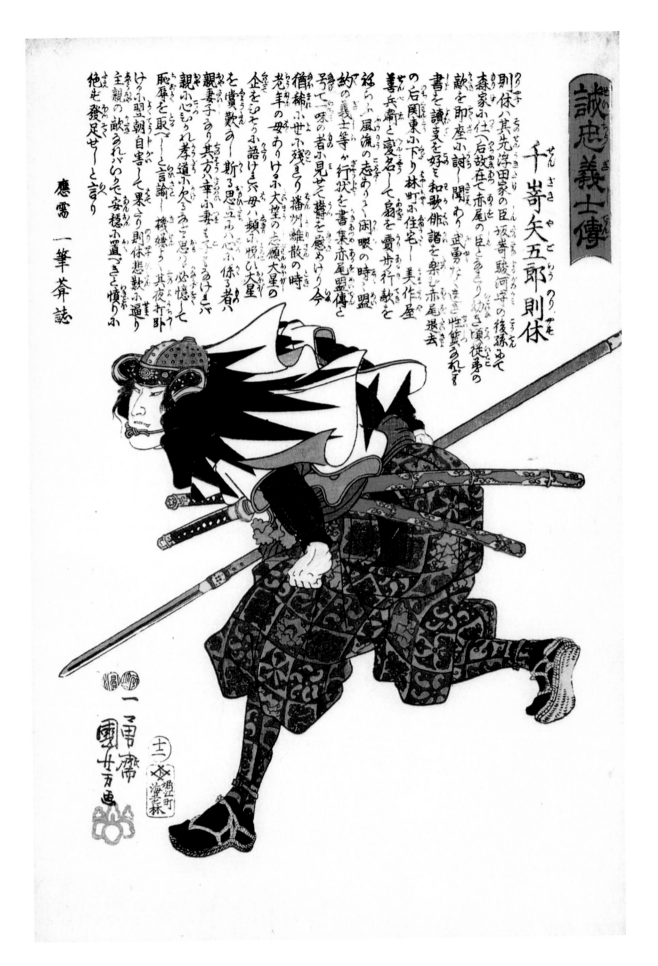

62. Senzaki Yagorō Noriyasu. The warrior running with his weapons.

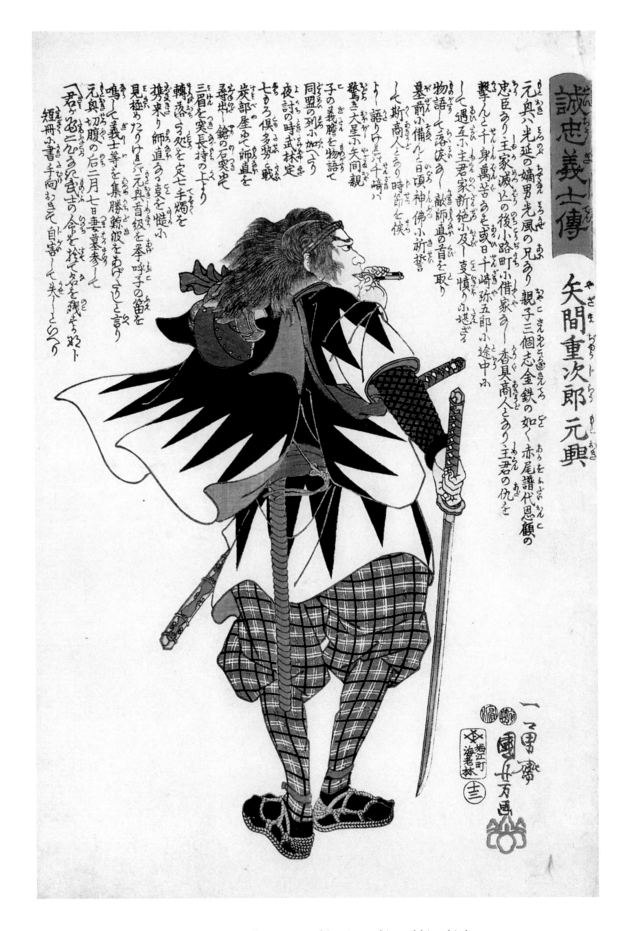

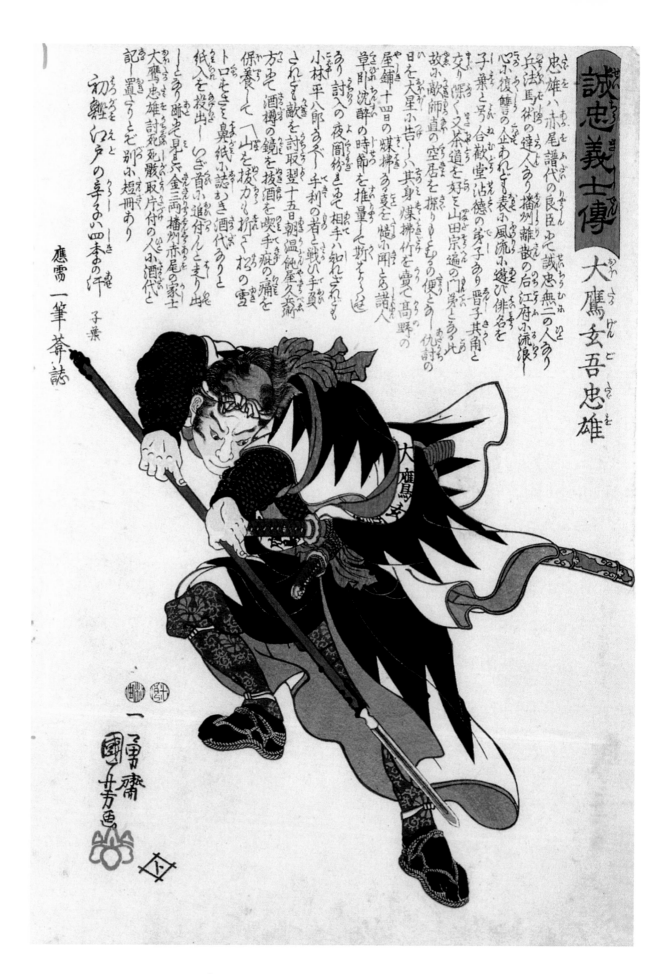

誠忠義士傳　大鷹玄吾忠雄

忠雄八赤尾譜代の良臣にして誠忠無二の人なり兵法馬術の達人なり播州離散の后江府に流浪心に復讐の企ありと表に風流に遊び俳名を子葉と號し合歓堂沾徳の弟子なり晋子其角と交り深く又茶道を好を山田宗遍の門弟となる此故に献師直の空居を探りをもの便とし仇討の日を大星に告し其身媒拂竹を賣て高野の屋舗十四日の媒拂ふ夫を傭に聞と諸人草鬥沈酔の時節を推量して斬そうとあり討入の夜間紛まきて相手に知れざるやうに小林平八郎あらで手利の者と戦八手賀されど敵を討取翌十五日朝温飩屋久齋に酒を汲て一喫手瓶の痛を保養して「山を援かる槭さ杉の雪」トロくをと鼻紙小誌にき酒代なりと紙入を投出しぎ首に進付んと走り出大鷹忠雄討死嚴取庁付の人小酒代とありとて跡史見て金三両播州赤尾の家士大鷹忠雄討死嚴取庁付の人小短冊あり記ー置らうとぞ別小短冊あり初離江戸の辛るの八四季の汗　子葉

應需　一筆菴誌

64. Ōtaka Gengo Tadao. The samurai takes aim with his spear.

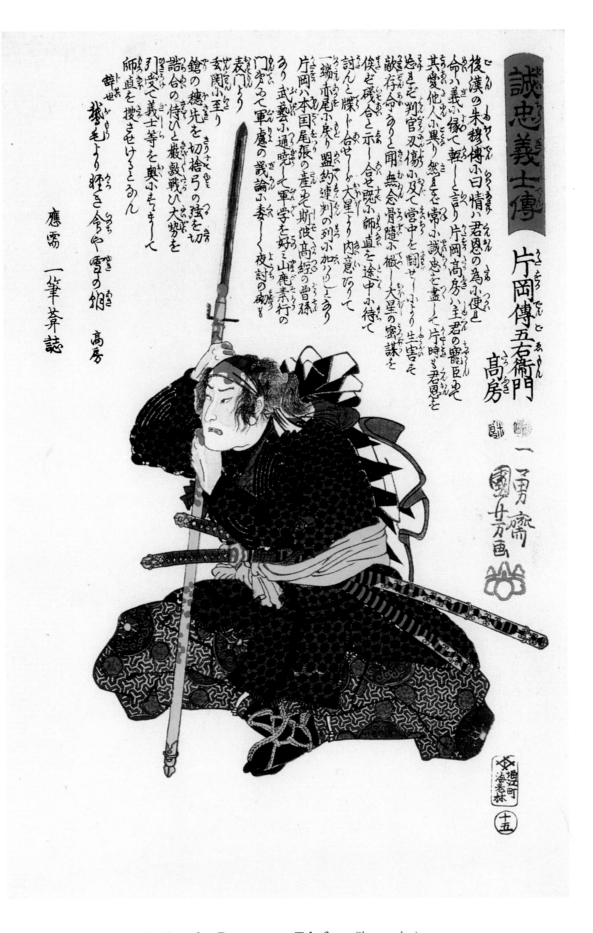

65. Kataoka Dengoemon Takafusa. Shown during a brief respite in the heat of battle, Kataoka is leaning on his bloodstained spear, with blood also spattered on his hands, swords, and headband.

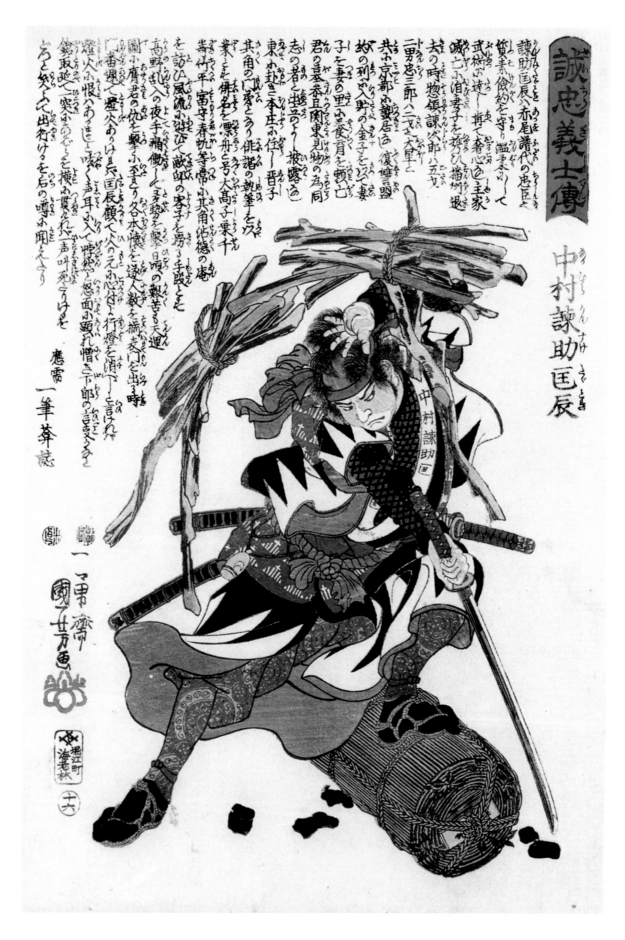

66. Nakamura Kansuke Tadatoki. In the midst of the
Kōno attack, Tadatoki encounters some hostile charcoal and
kindling wood in the mansion's kitchen area.

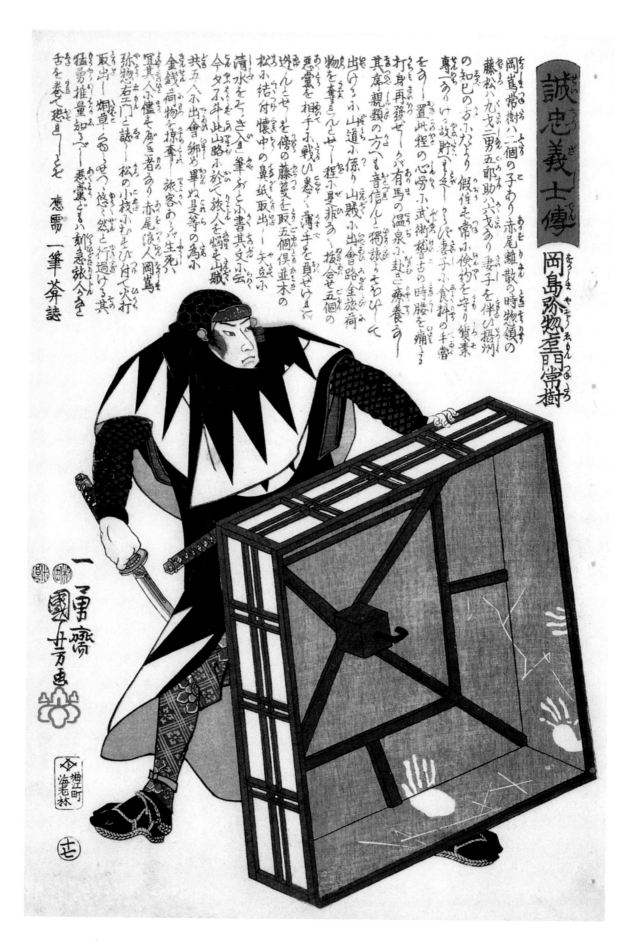

67. Okashima Yasōemon Tsunetatsu. In another quasi-domestic scene, Okashima finds some impromptu protection behind the cover of an *idō* or floor fireplace.

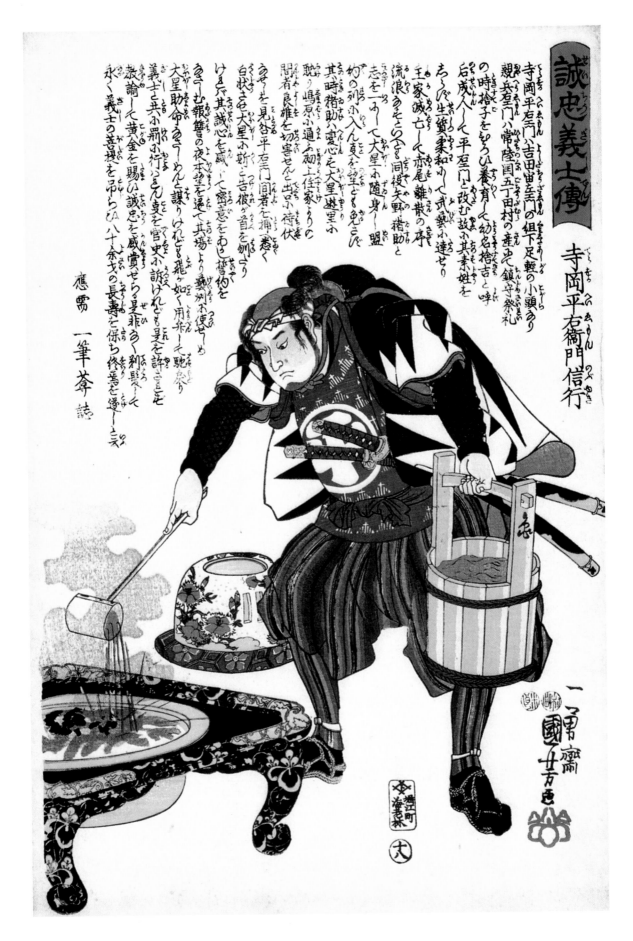

誠忠義士傳

寺岡平右衛門信行

寺岡平右衛門ハ吉田忠左衛門の組下足軽の小頭なり親兵衛門ハ常陸國五丁田村の産なりしが鎮守祭礼の時捨子をひろひ養育して幼名捨吉と呼び成人へて平右衛門と改む故に其素姓をもらざべ生質柔和にして武藝に達せり主家滅亡にて赤尾雉蔵の序流浪をなせしを同役矢野猪助と志を一にして大星の随身し幼の列に入んことを望どももらさず其時猪助の意心ぞ大星遊里に聞し嶋原に通ひ初め土住家よりの聰者良雄を切害せんと出来待伏るやそを見咎め平右衛門新に吉田の新を訴白状させ大星に新に吉田の志を見とほし大星助命をもらして其報讐の夜本望を遂げんと謀りけれども飛ぬ如く用捨されど其場より義烈に便せしけれ義士と其小罰小行ひし夜官史に訴りけれど是を許さずとぞ教諭して黄金を賜ひ誠忠を感賞せられる是非なく新髪へて永く義士の菩提を吊らん八十余歳の長壽を保ち終善を遂しとぞ

應需 一筆菴誌

68. Teraoka Hei-emon Nobuyuki. The loyal Hei-emon extinguishing the fire in a hibachi. Before leaving the Kōno mansion, the attackers under Ōboshi were careful to extinguish all fires to insure that none of the neighbors' houses would be destroyed accidentally.

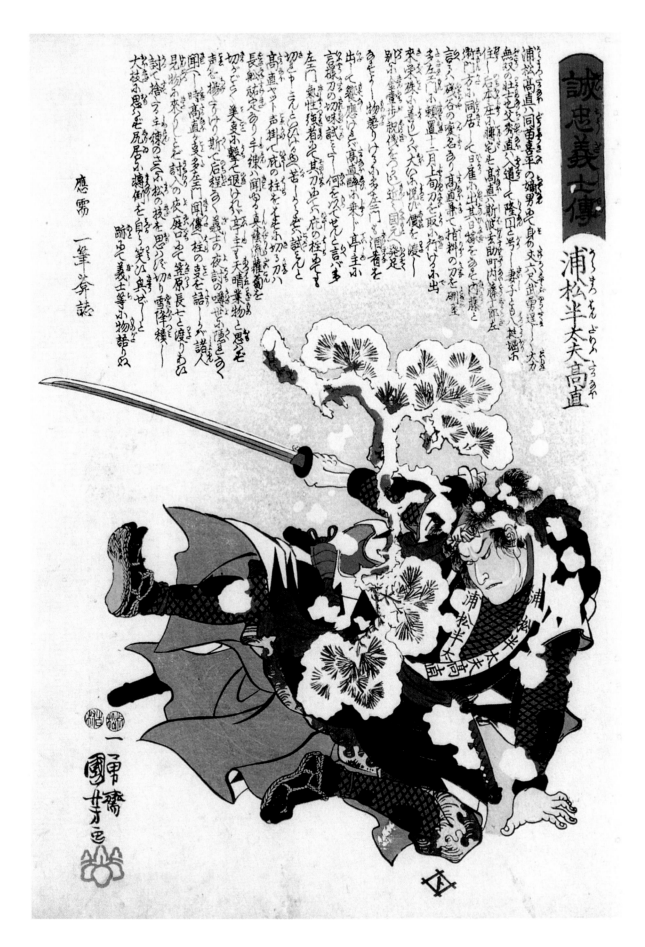

69. Uramatsu Handayū Takanao. Takanao was a master swordsman and often practiced his technique by felling pine branches. On at least one occasion a large branch covered with snow knocked the samurai over backwards, a story he laughed about with his comrades.

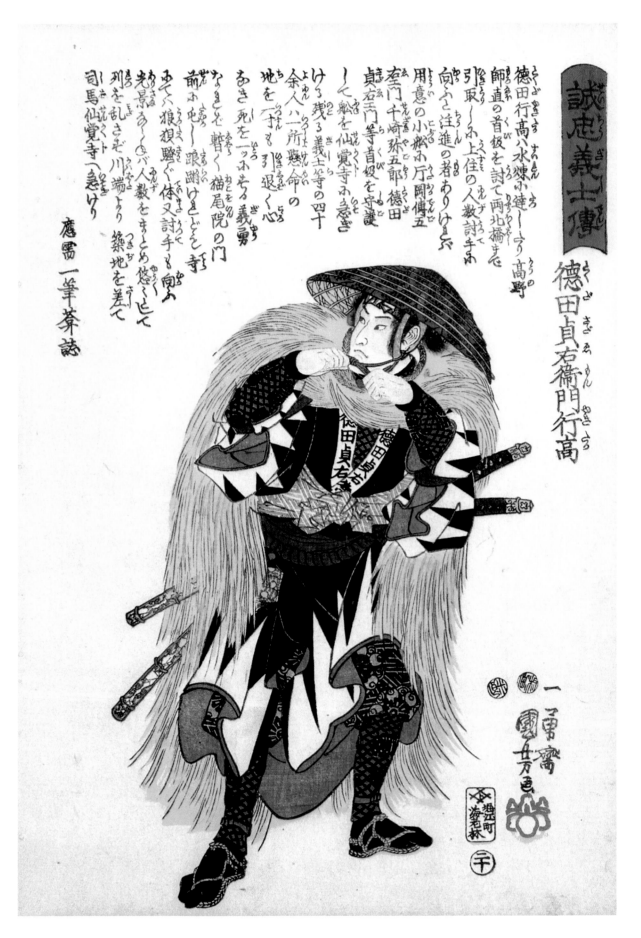

誠忠義士傳

徳田貞右衛門行高

徳田行高八水練小達し高野
師直の首級を討て兩北橋より
引取小上住の人數討手甲
向ふと注進の者ありけとぞ
用意の小舩小庁岡傳五
奎門千崎弥五郎徳田
貞右衛門等首級を守護
し舩を仙覺寺ふ急ぎ
あき死を一つ返る義勇
なきとを暫く猫尾院の門
前ふ心一跟蹰けとど寺
子へ狼狽騒ぐ体又討手を
光景一バ人数をまとめ悠さと
列を亂さぞ川端より築地を差て
司馬仙覺寺へ急けり

應需 一筆菴誌

残る義士等の四十
余人ハ一所懸命の
地を守らん引退く心
地を仙覺寺ふ急ぎ

70. **Tokuda Sadaemon Yukitaka.** The samurai wears a broad hat and a straw mantle to protect his armor and equipment from the rain.

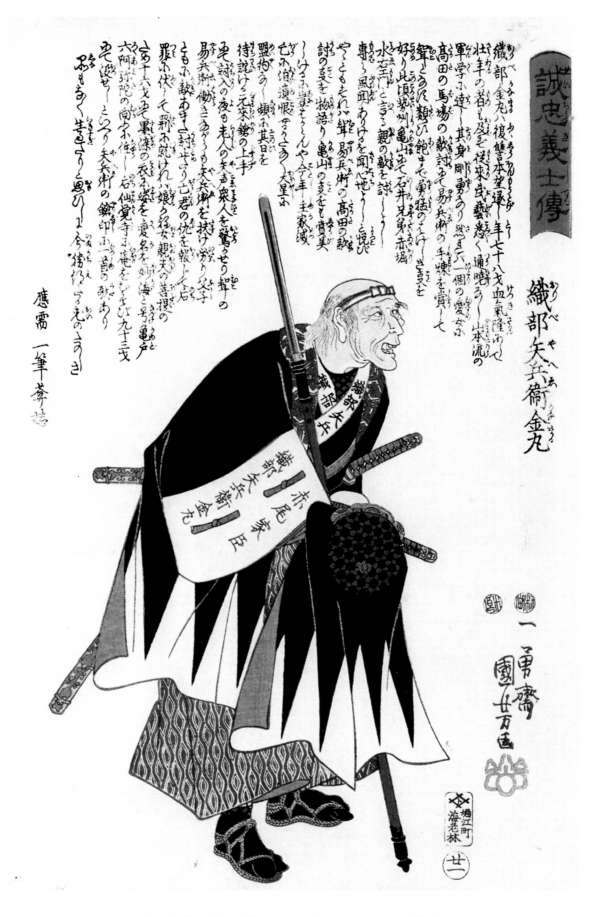

71. Oribe Yahei Kanamaru. Kanamaru was, at 78, the oldest warrior to take part in the Kōno attack. He was especially skillful with the spear and did well in the battle. The banner on his spear identifies his name and clan.

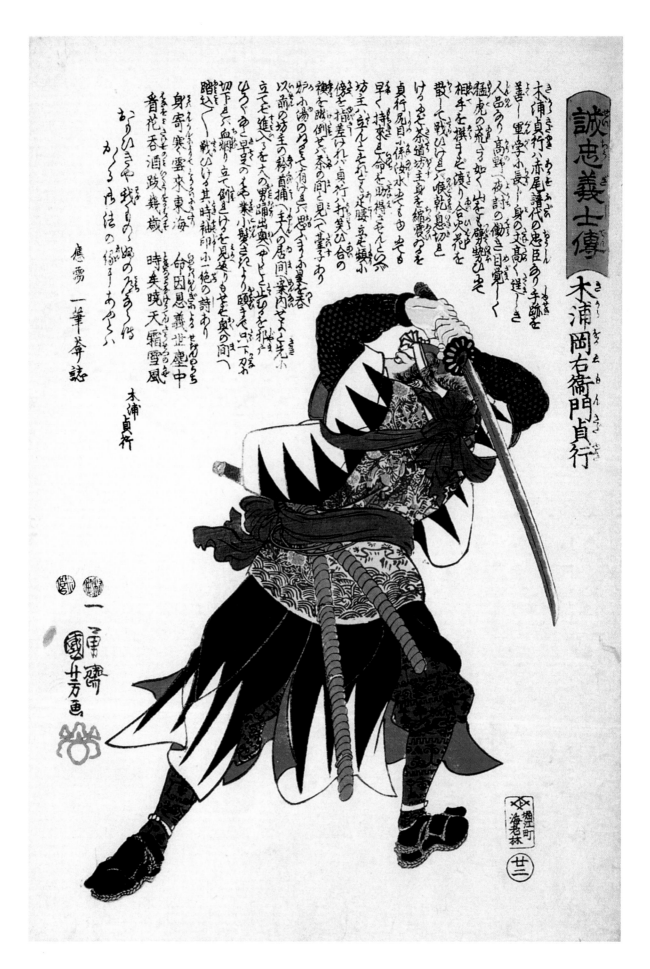

72. Kiura Okaemon Sadayuki. The samurai poised to strike with his sword.

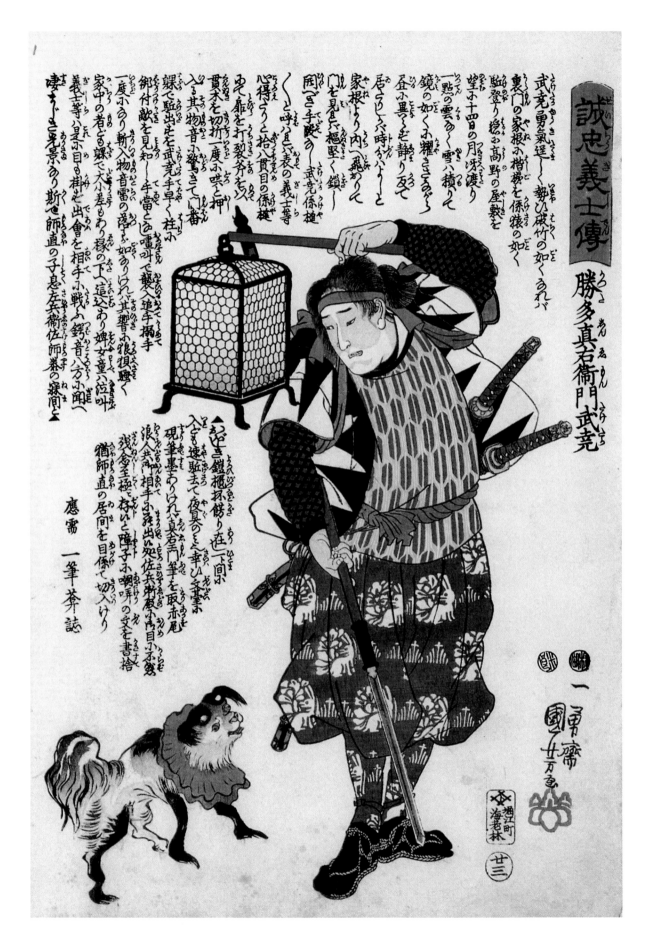

73. Katsuta Shinemon Taketaka. A humorous remind- er that the Kōno attack took place at night, the heavily armed samurai is here also burdened with a large and clumsy lamp when he encounters an elegant small dog in the Kōno mansion.

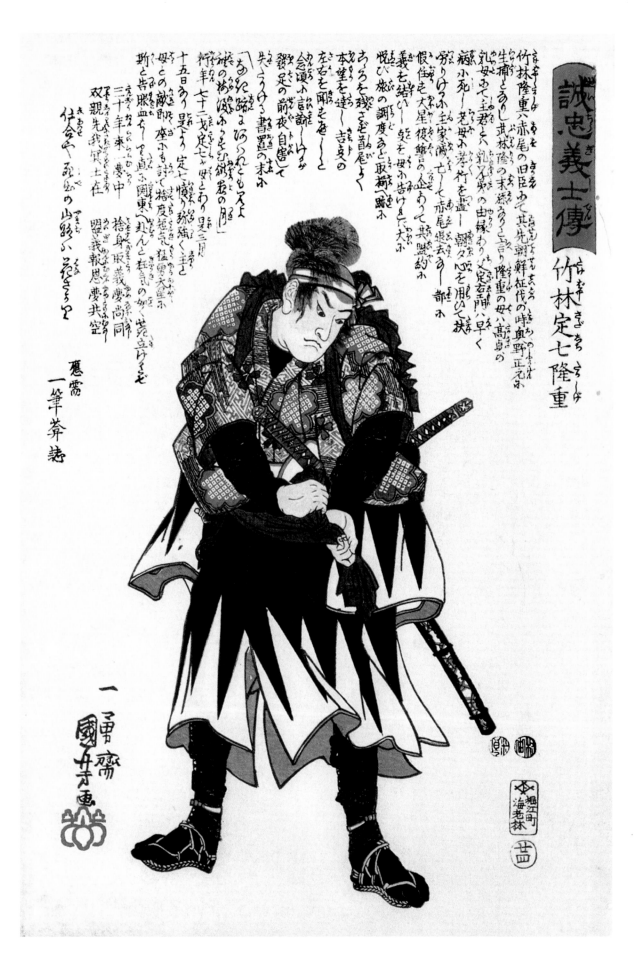

74. Takebayashi Sadashichi Takashige. The samurai
tying his waistband before the battle.

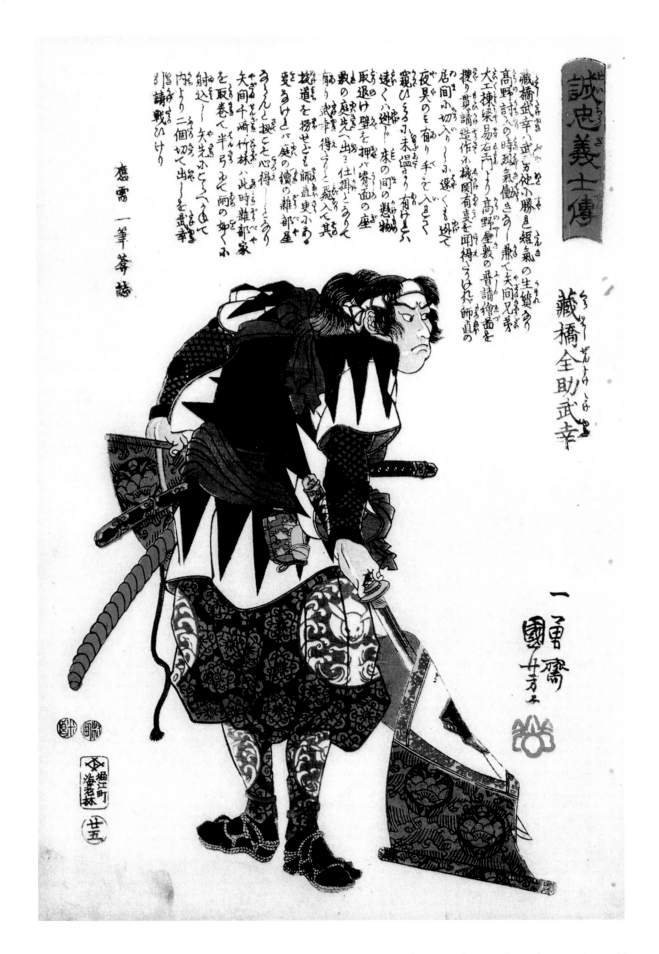

應需 一筆菴誌

誠忠義士傳

藏橋全助武幸

一勇齋
國芳

75. Kurahashi Zensuke Takeyuki. Takeyuki was in on the finish at the Kōno mansion when the enemy Moronao was discovered in the storage shed in the garden. In this print he stands in the mansion with a displaced wall scroll over his sword.

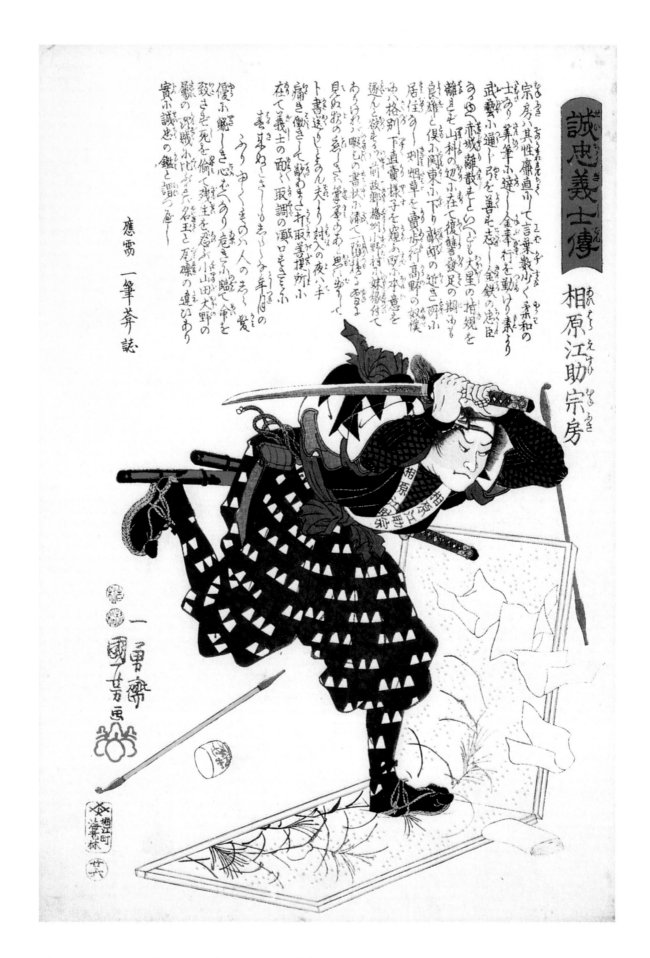

76. Aihara Esuke Munefusa. Munefusa running at full tilt brandishing his sword. He is running over a low screen which has been knocked over. The flying cup, long pipes, and sheets of writing paper indicate that a domestic scene has been interrupted in this attack.

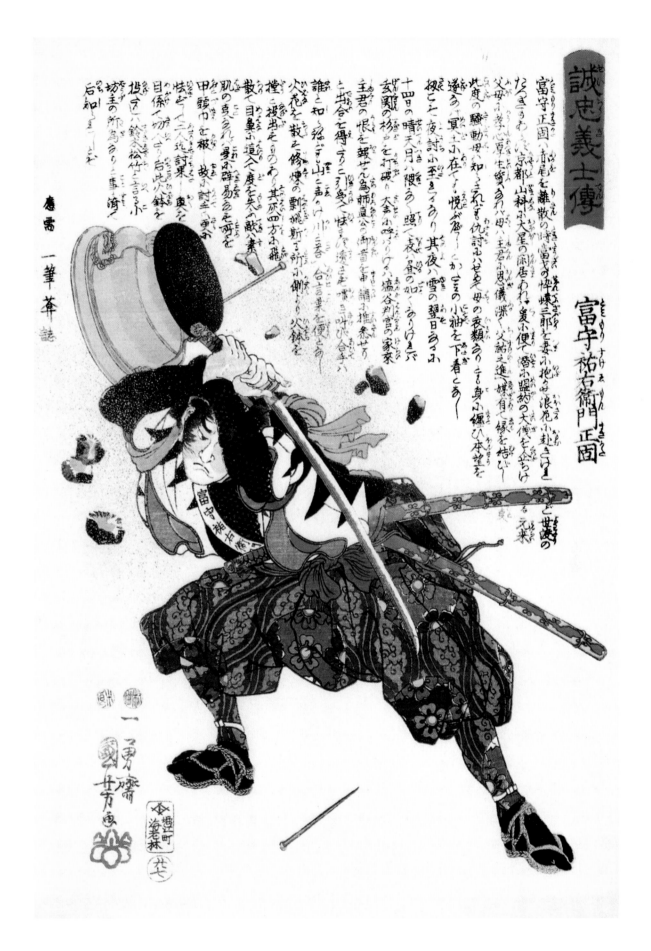

誠忠義士傳

富守祐右衛門正固

77. Tominomori Suke-emon Masakata. Tominomori dodges a hibachi thrown at him during the Kōno attack. The printmaker applied metallic powder to the print after printing this image to indicate the coal dust thrown up by the hibachi.

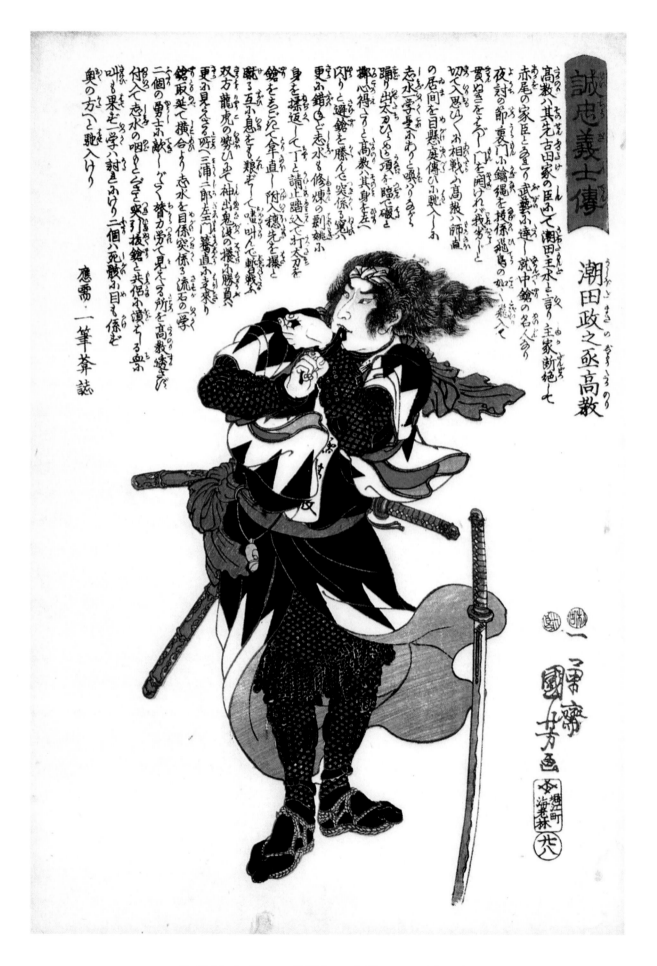

78. Ushioda Masanojō Takanori. The samurai fastening
his wrist strap.

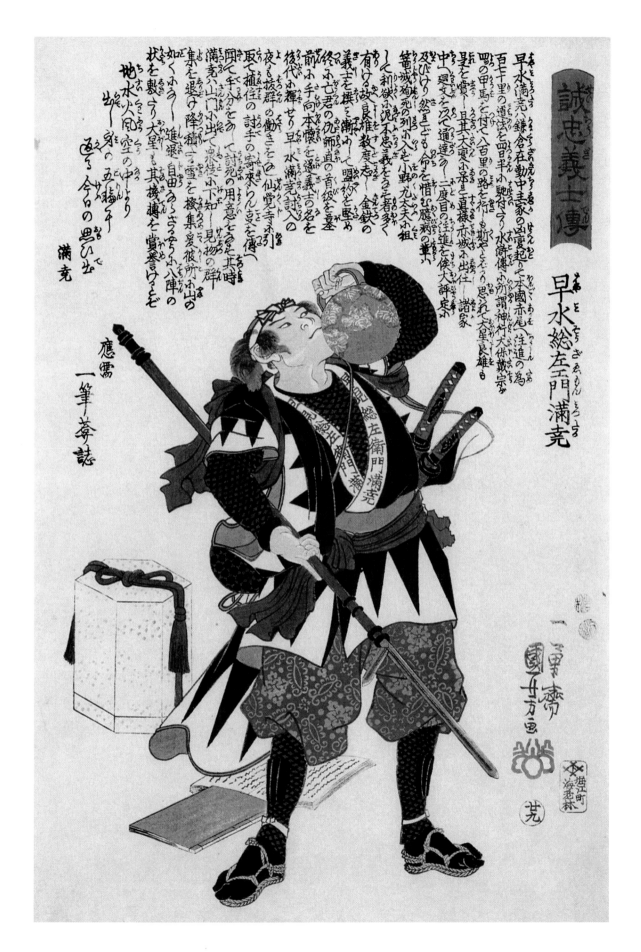

誠忠義士傳

早水總左衛門滿尭

早水滿尭ハ鎌倉在勤中圭家の凶變起り本國赤尾に注進の爲百七十里の道法を四日半に馳付るゝ水滸傳に所謂神行太保戴宗が四の甲馬を付て八百里の路を行りと斯やうに思れて大星良雄も星を實に早其大寮小弟と直様赤城へ出仕し諸家中へ觸達り二度目の注進を候大評定あるに及ぬ滿尭に命を惜む臆病の輩あり利欲小泥不忠義をそる者多く小野九太夫小祖篭城殉死の列外へ入ぞ金鐡の有ける故良雄教度志し金鐡の義士を撰み盟約と座め終に滿尭も亡君の仇師直の首級を墓前に小手向けて早水滿尭討入の後代々輝せり早水滿尭本懷を遂義の名を挙けるゝ仙覺寺の寄來より討死の用意とゝ其時夜に挨群の働きをし取て植住の討手の群集を退け降積る雪を撥集爰很所小山の岡天へ手分をと見物の群岩如くふるに進退自由ふさゞふ八陣の状を敷う大星も其機撫を賞譽けるとぞ地水火風空の中より一身の五輪子に出るこゝ今日の思ひ出

滿尭

應需
一筆菴譽誌

79. **Hayami Sōzaemon Mitsutaka.** Hayami Mitsutaka drinking from a kettle after the Kōno battle was over. The six-sided box behind him no doubt contains the prize the 47 rōnin came there for, the severed head of the enemy Moronao.

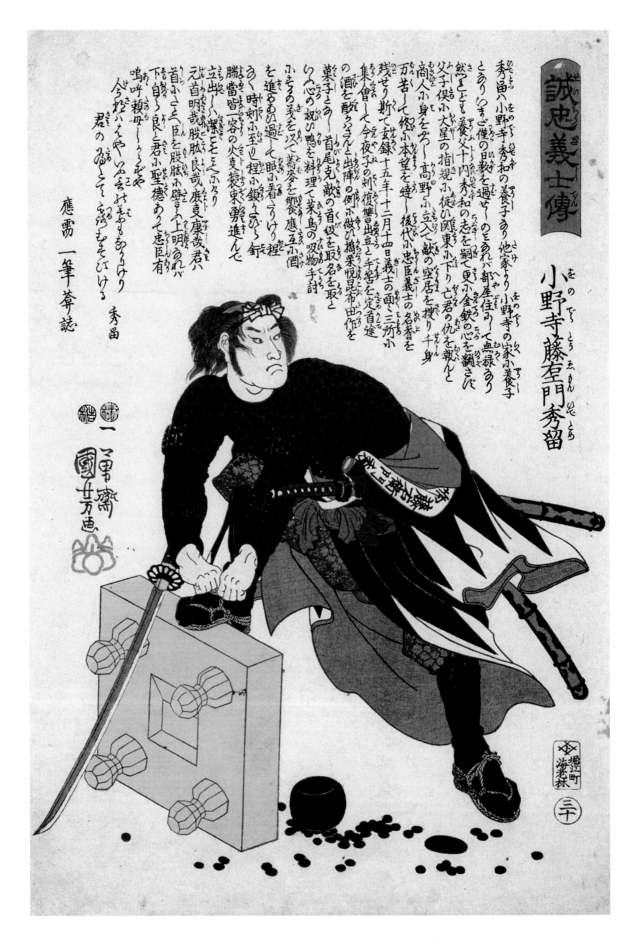

80. Onodera Tōemon Hidetome. The great warrior Hidetome adjusting his sandal on the edge of a tipped-over *go* board with the black pieces strewn on the floor.

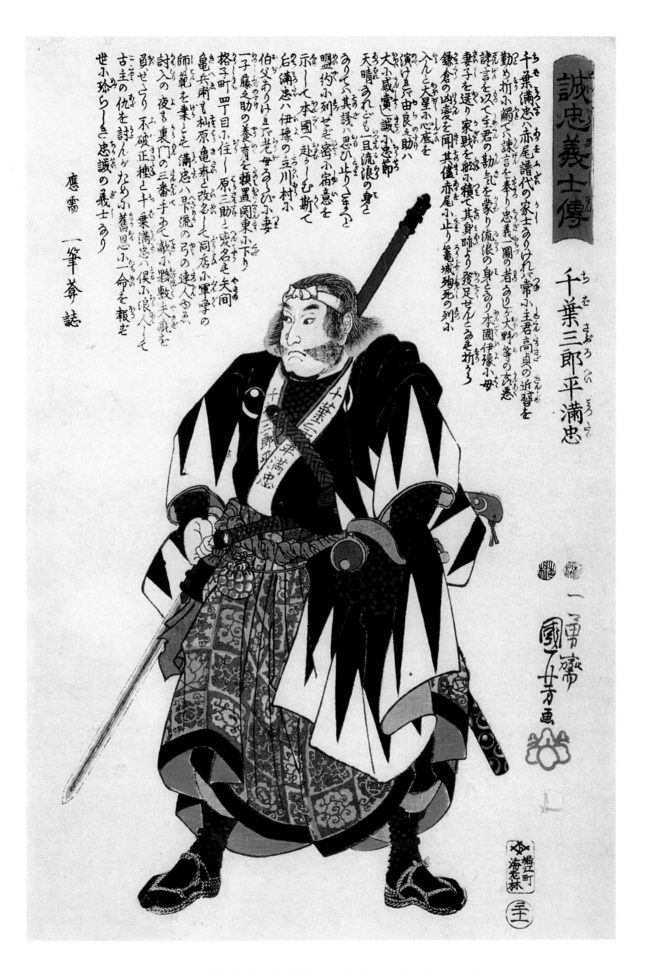

81. Chiba Saburōhei Mitsutada. A portrait of a samurai ready for battle.

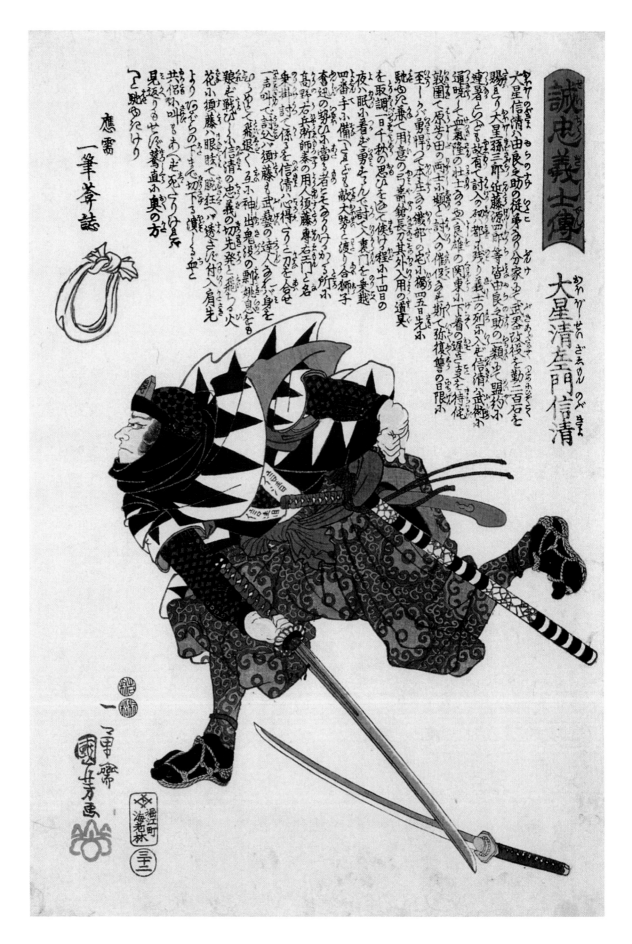

82. Ōboshi Seizaemon Nobukiyo. Nobukiyo was a martial arts expert who has here delivered such a devastating blow to an unseen opponent that his victim's sword is shown flying off in one direction and his headband in another.

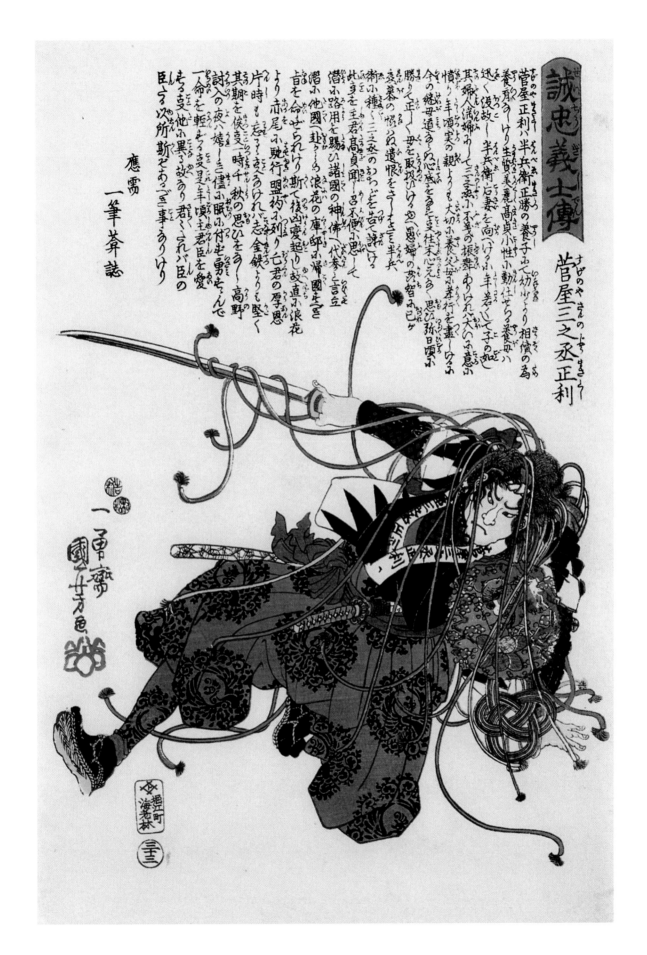

世ち忠ぎ義士伝

菅すがのやさんのじょうまさとしや三之丞正利

83. Sugenoya Sannojō Masatoshi. In another amusing domestic contretemps during the Kōno attack, Sannojō is shown getting the worst of it from the streamers of a *kusudama,* a scented ball used in clothes closets and other private rooms.

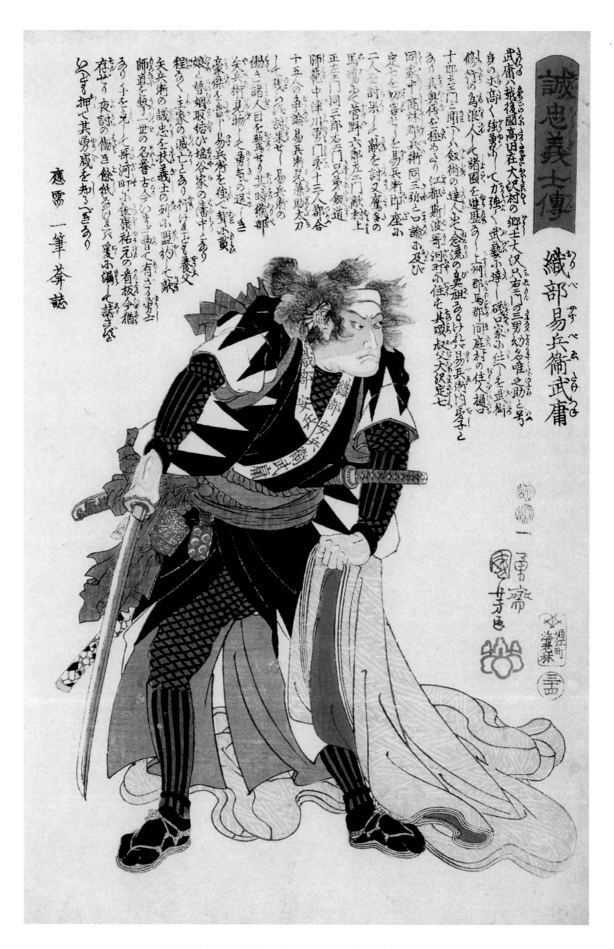

84. Oribe Yasubei Taketsune. Yasubei, a ferocious and accomplished warrior, holds the sleeping robe of the defeated enemy Moronao after the Kōno attack.

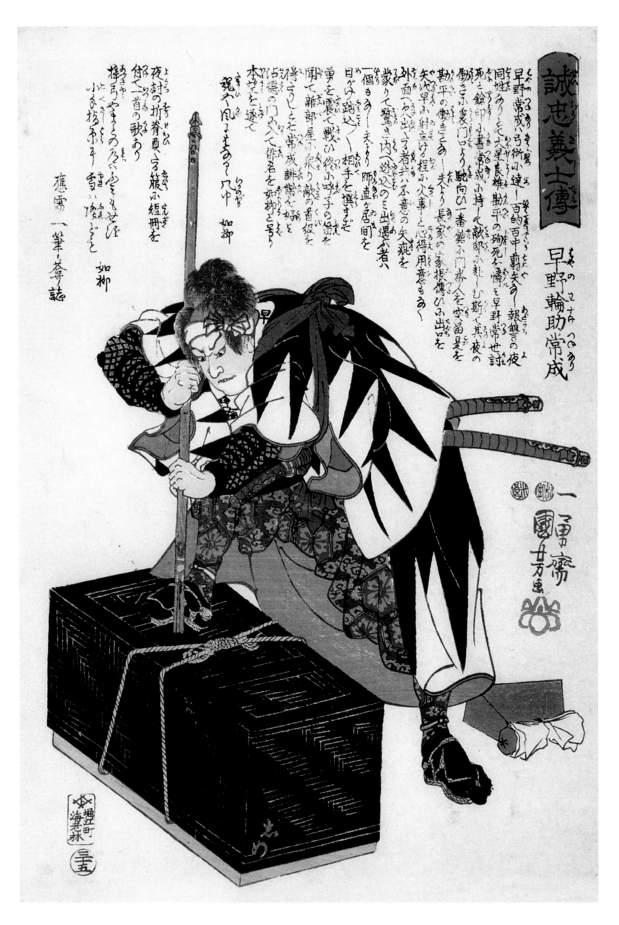

85. Hayano Wasuke Tsunenari. The samurai is probing a sealed chest with his spear, possibly searching for the enemy in hiding, Moronao. Tsunenari was present at the climax of the night attack when Moronao was beheaded.

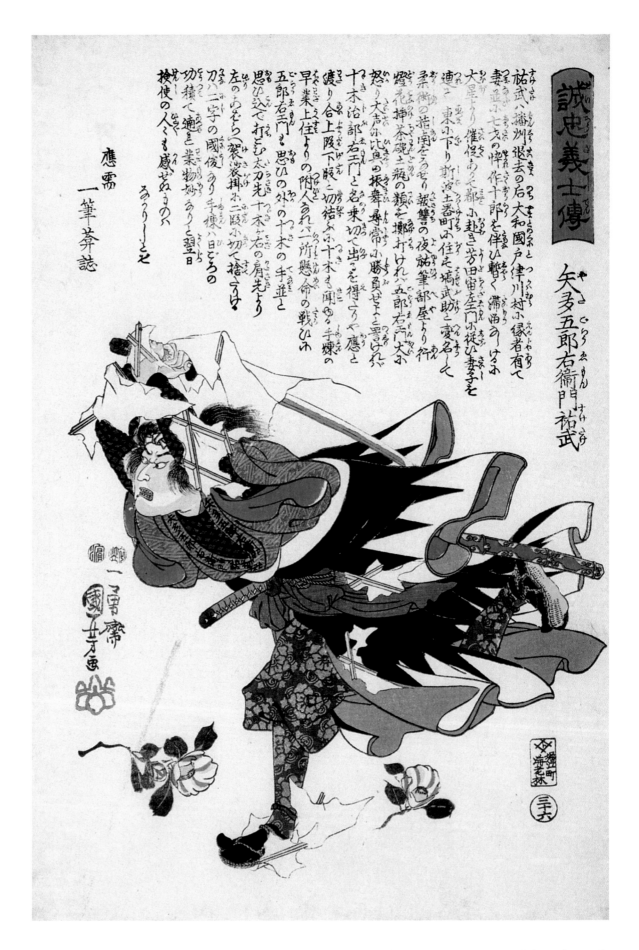

誠忠義士傳

矢多五郎右衞門祐武

86. Yata Gorōemon Suketake. Another reminder that the Kōno attack was an assault on a residence, Suketake is depicted fighting his way deeper into Moronao's mansion, scattering flowers in the process and here dismantling a *shoji*, a sliding panel of translucent paper used as a door or window.

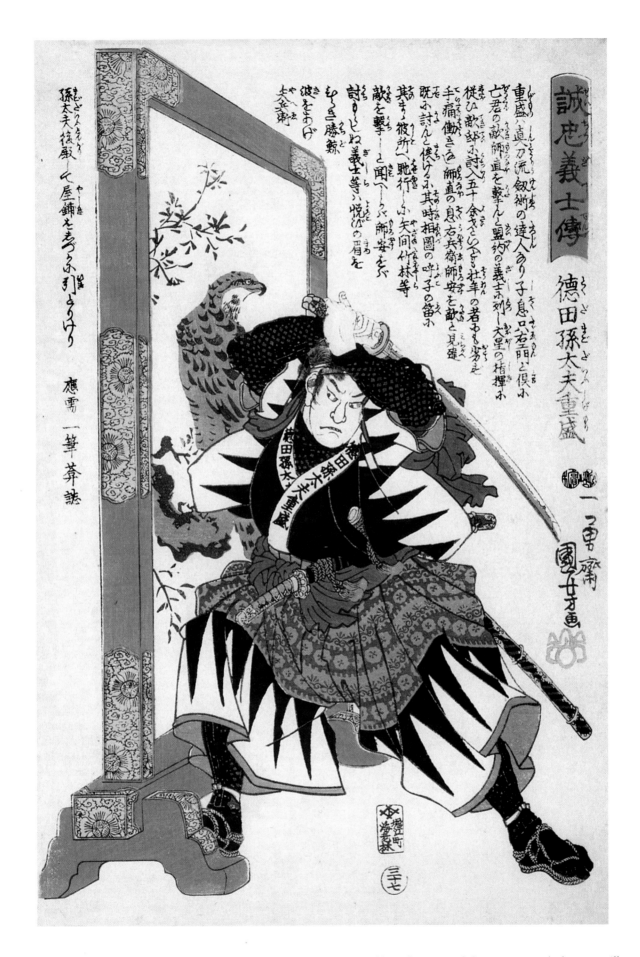

87. Tokuda Magodayū Shigemori. Poised with upraised sword behind a painted screen, Shigemori is ready for action. The text related that though he was 50 years old at the time of the Kōno attack, he was still as effective a warrior as his younger comrades.

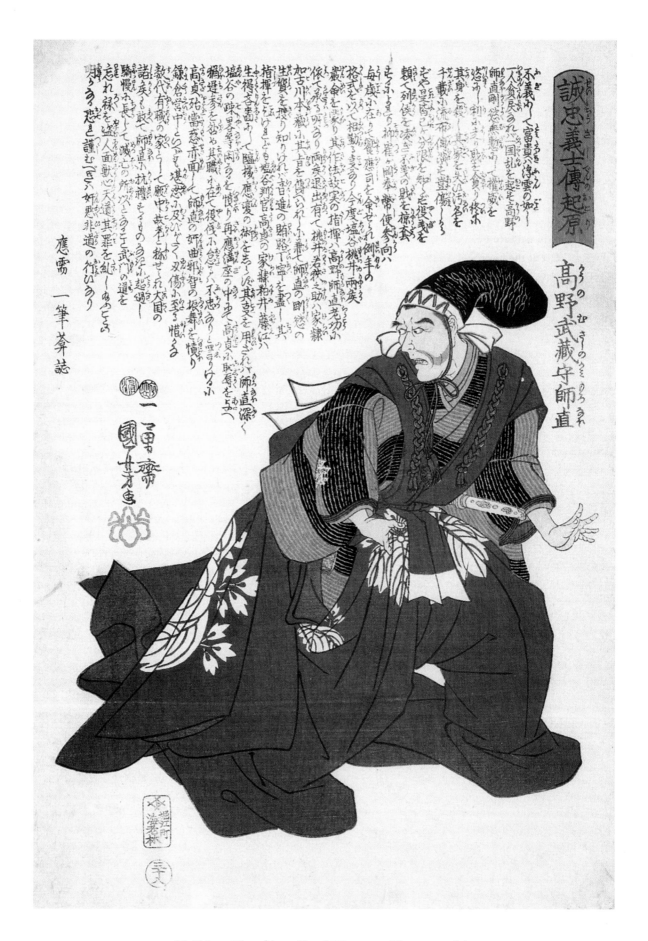

88. Kōno Musashi no Kami Moronao. The target of the
Kōno attack, Moronao, wearing ceremonial dress appropriate
for formal occasions, is shown cowering in fear at the time of
the attack on his mansion by the 47 rōnin.

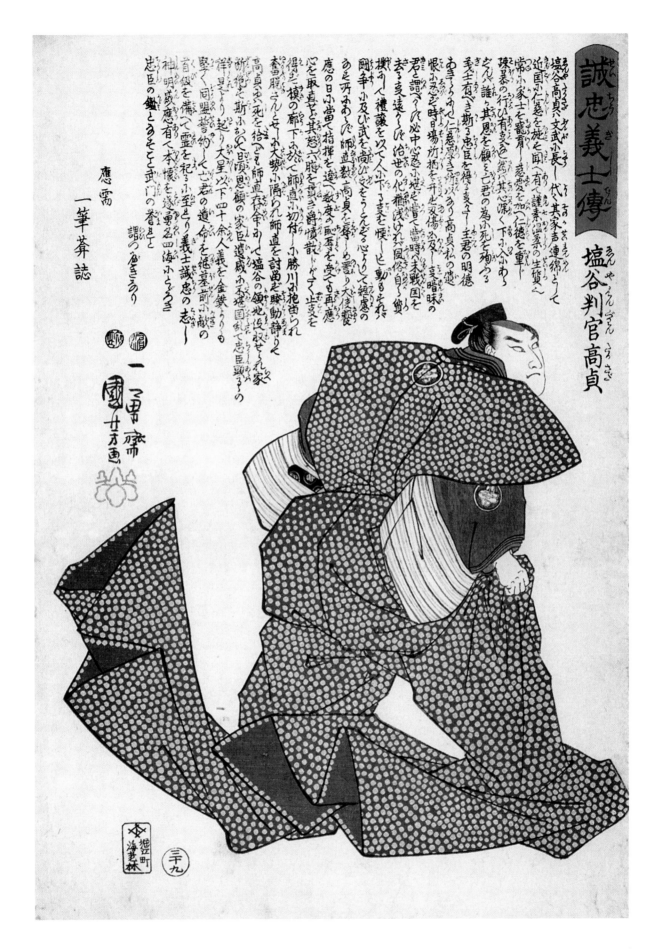

誠忠義士傳　塩谷判官高貞

塩谷高貞は文武兼長して代々其家吉連綿として近国小仁慈を施す聞く常小家士を寵育し慈愛を加へ〔有て謹素温泉の生質へ〕珠碁の行ひ有さて其心漏く下ふへふどんな誰か其恩を顧み亡君の為小死を殉ふ義士有べき斯て忠臣を得るまし主君の明徳あきらかく仁慈きさせんにより高貞小私の怨恨小ふぶ時日場防柄を升め交傷ぶ小支援君と謂べく必中心怒小地之當時八未戦国を去る支遠らふは給世の化褐浅はれ小風俗自ら質横すく禮義を以て人小下るまを懐へ

89. En'ya Hangan Takasada. Lord Asano, in ceremonial dress. His outburst against Moronao, followed by his forced suicide and the devastation of his clan, prompted his devoted retainers, the 47 rōnin, to organize to take revenge on their enemy Moronao.

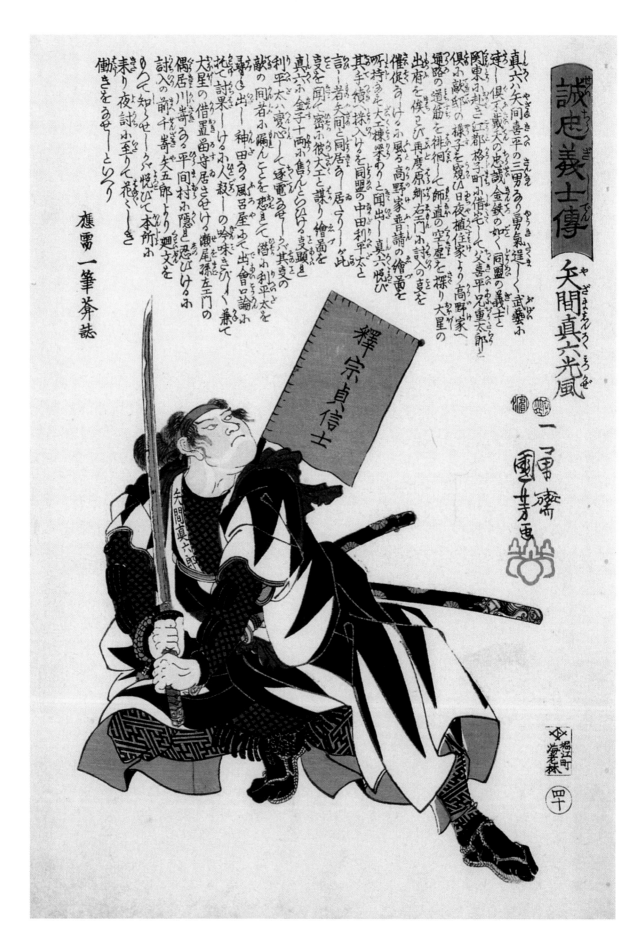

90. Yazama Shinroku Mitsukaze. A brilliant soldier,
Shinroku wears a flag in battle bearing his "death name,"
the name he wished to be remembered by.

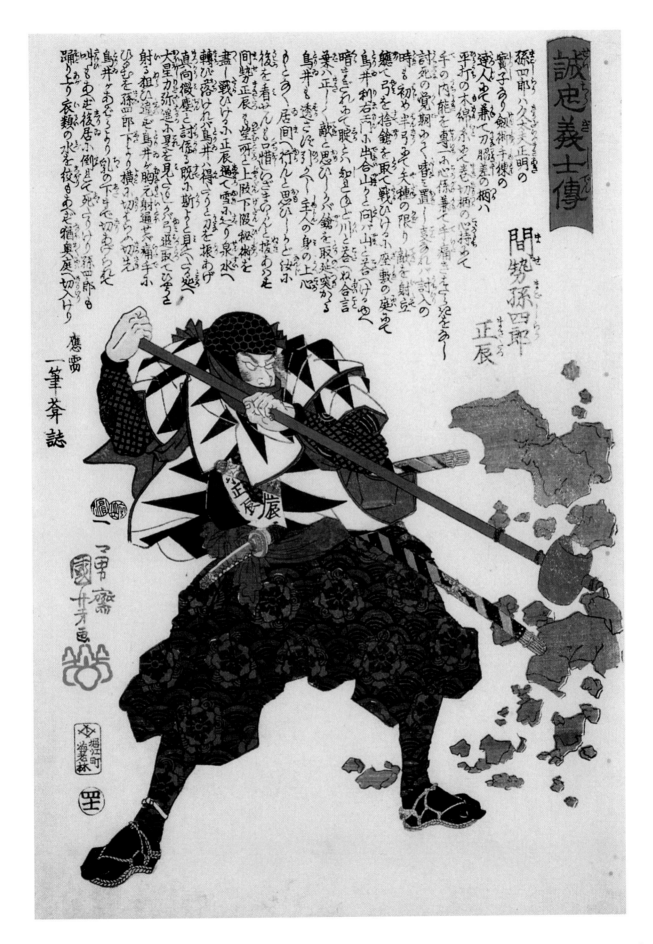

91. Mase Magoshirō Masatatsu. Masatatsu smashing an earthen vessel with a long mallet. The text relates that Masatatsu's hands were too sore from blisters for him to use his sword in the Kōno attack, so instead he did a lot of damage with his spear. The circumstances of the mallet attack on the vessel were not explained.

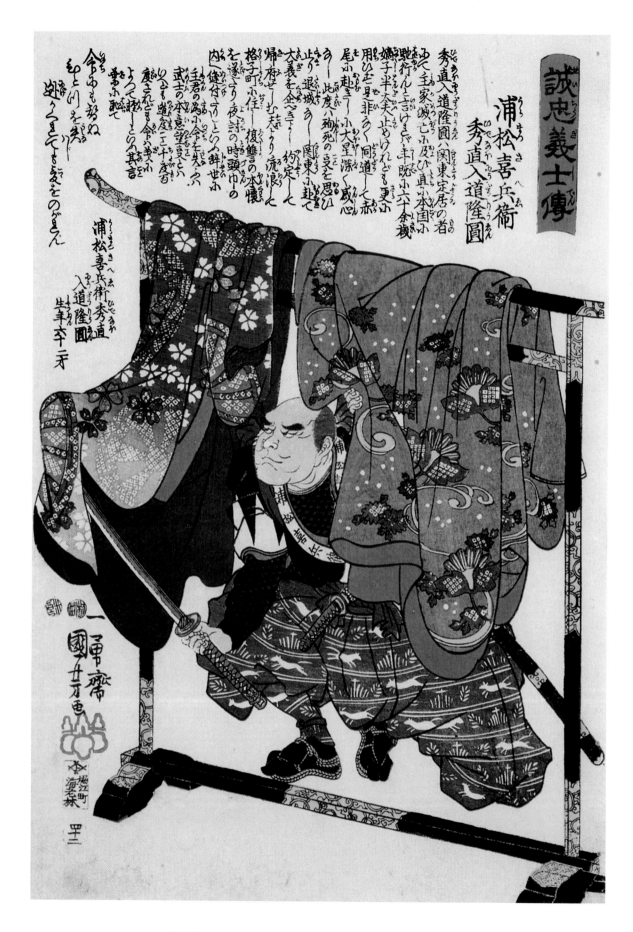

92. Ryūen, Uramatsu Kihei Hidenao. Ryūen was a lay priest as well as a samurai. Here he takes cover, sword at the ready, behind a rack of elegant kimonos, a scene no doubt intended to be gently humorous.

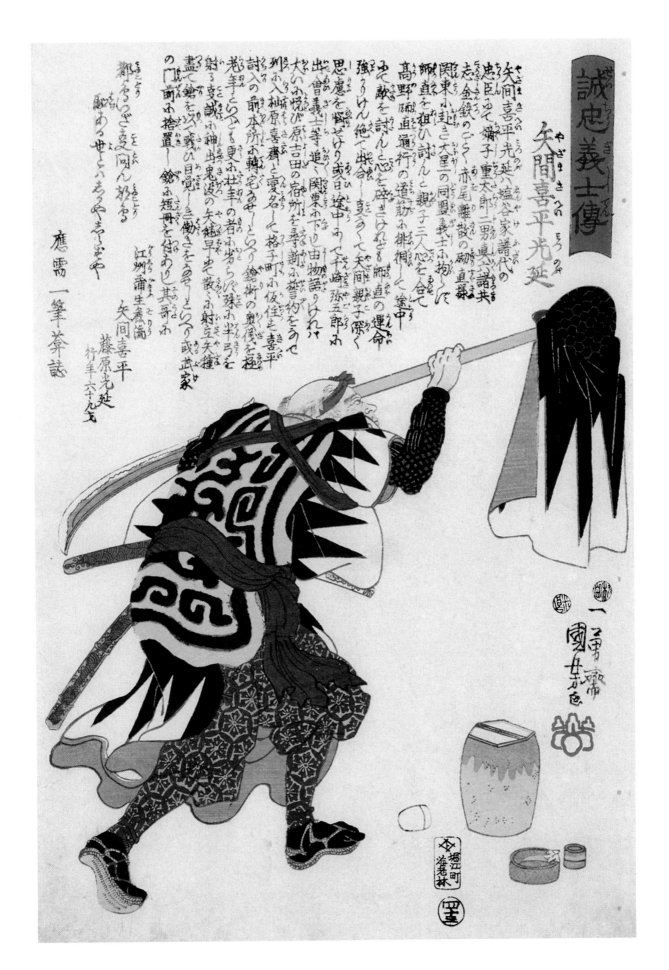

93. Yazama Kihei Mitsunobu. The samurai is carrying
his helmet and cape on the blunt end of his spear.

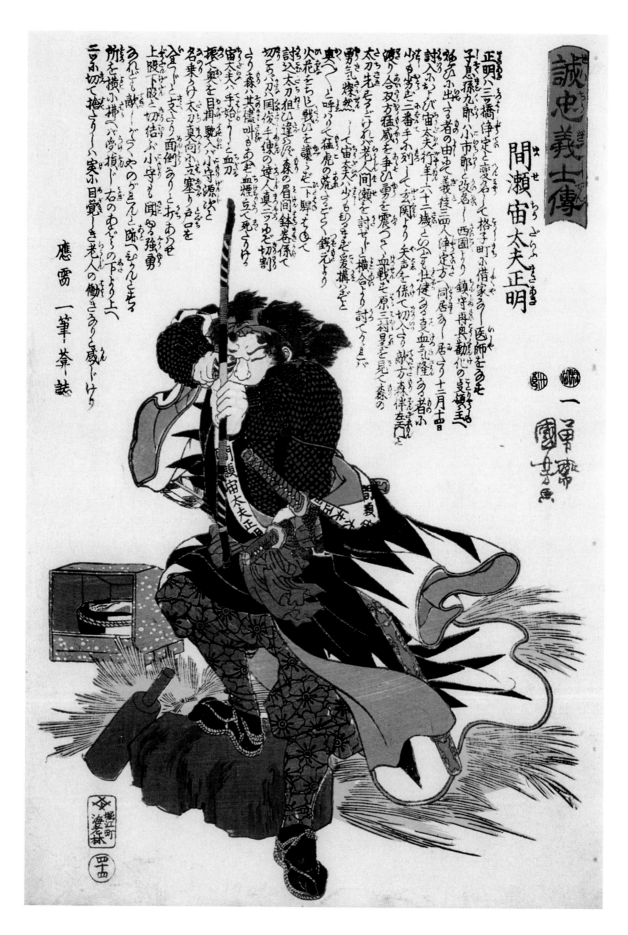

94. Mase Chūdayū Masa-aki. Mase was over sixty at the time of the Kōno attack but still a formidable warrior and expert with the bow. In this *trompe l'oeil* print, the arrow points directly at the viewer from any angle.

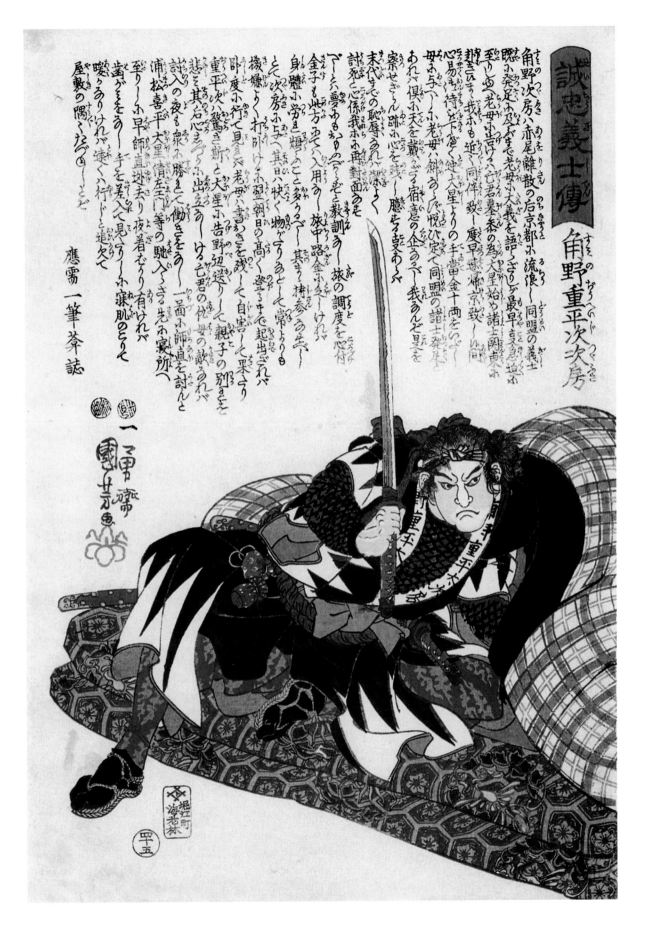

95. Sumino Jūheiji Tsugufusa. Jūheiji feeling the empty bed of the enemy Moronao as the Kōno attack was nearing its end. Finding the bed still warm, the samurai knew that Moronao must be in hiding nearby.

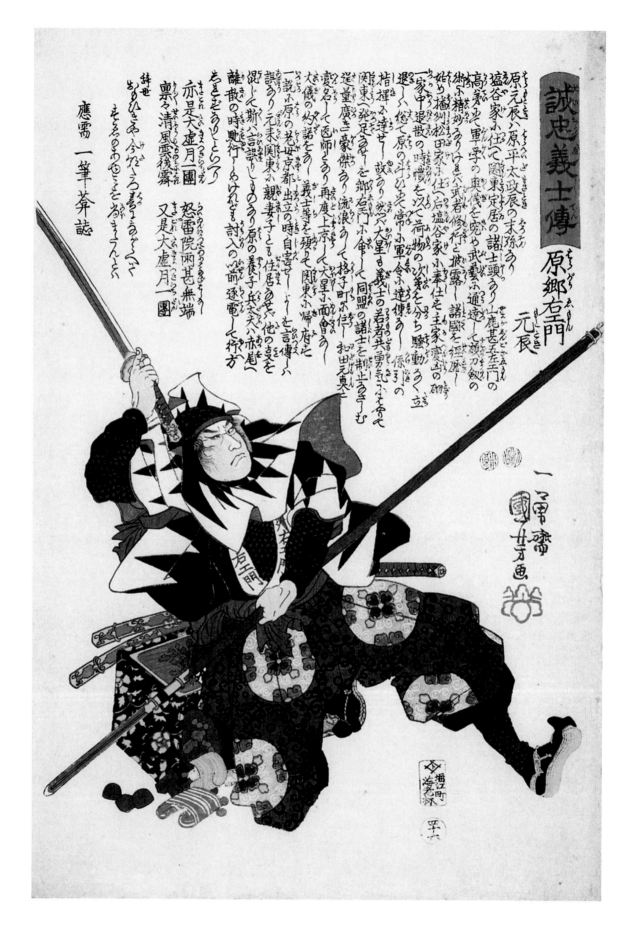

96. Hara Gōemon Mototoki. The samurai is seen here with upraised sword in one hand and spear in the other. There was no armor for the samurai's feet, however; they were typically protected only by the straw sandals depicted here.

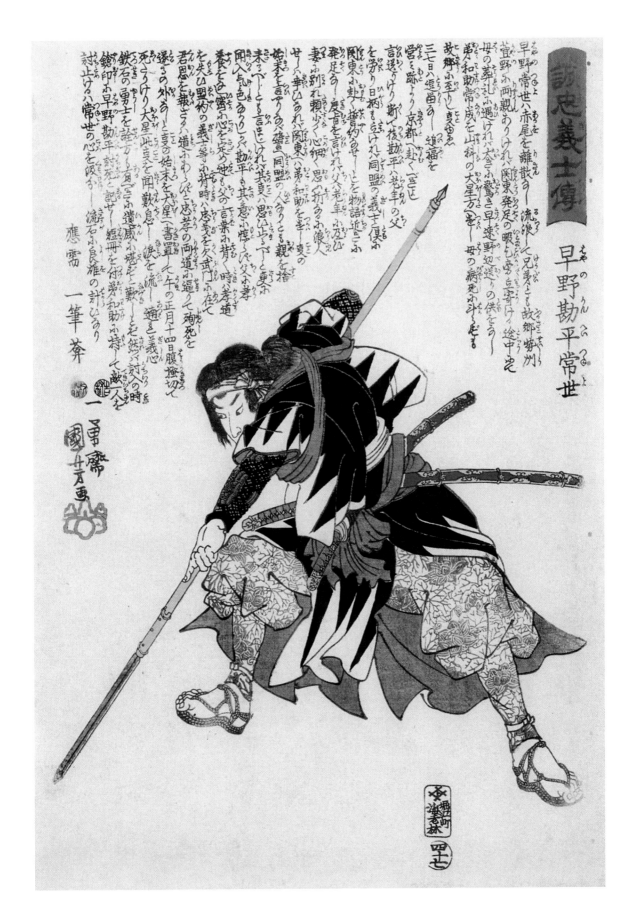

應需　一筆菴

97. Hayano Kampei Tsuneyo. Kampei is portrayed as a ghost-like figure with pale skin tones and muted clothing. He missed the Kōno battle because he committed suicide before it took place, torn by an unresolvable conflict between his desire to fight with his rōnin comrades on the one hand and his need to obey his aged father's command to remain at home and care for him on the other. Suicide was the only honorable way out. In the battle the rōnin leader Ōboshi ordered Kampei's brother to carry a spear with his brother's name, "Hayano Kampei, killed in battle."

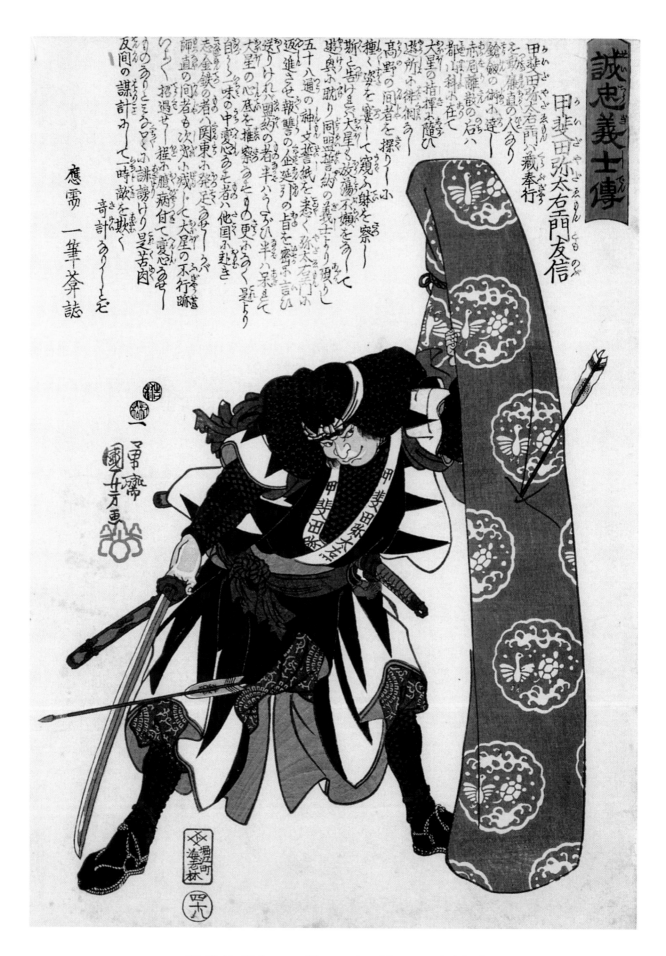

98. Kaida Yadaemon Tomonobu. The samurai defends himself from enemy arrows behind a covered *koto,* a stringed musical instrument.

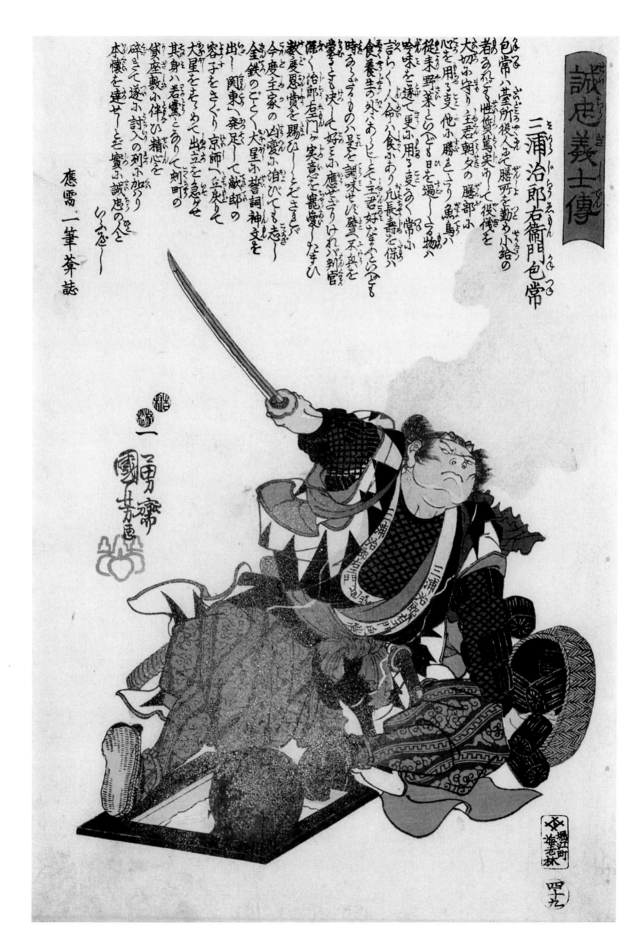

99. Miura Jirōemon Kanetsune. Kanetsune was a low‑ranking samurai who basically served his lord as a chef. He took part in the Kōno attack and is portrayed somewhat comically here, having fallen into a hearth, sword in hand, and overturned a basket of charcoal. Metallic powder was applied to the print to simulate the coal dust stirred up by this action.

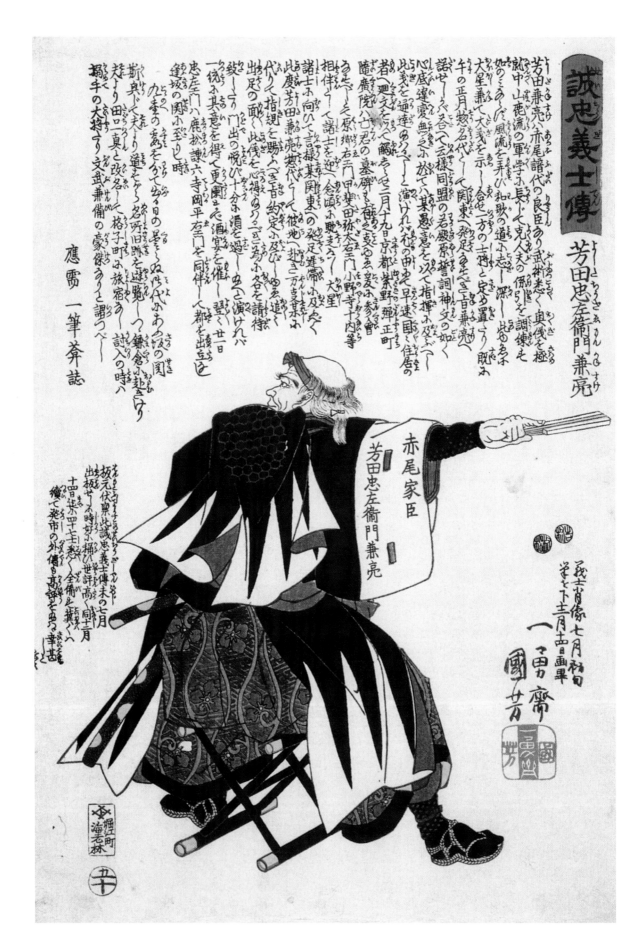

誠忠義士傳

100. Yoshida Chūzaemon Kanesuke. Yoshida was, like many other samurai, an accomplished poet. Here he is pointing with a *jin-sen,* a battle fan used by warriors in Kabuki theatre. The banner on his sleeve identifies him as one of the faithful rōnin, a retainer of Lord Asano.

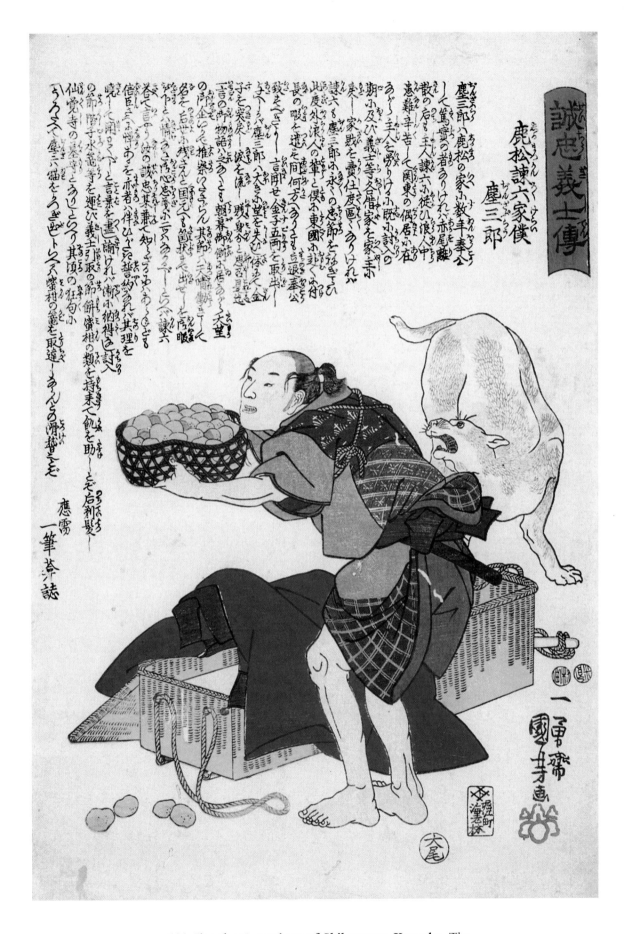

101. Jinzaburō, retainer of Shikamatsu Kanroku. The last print in the series portrays Jinzaburō, a servant of one of the rōnin, standing in front of his huge box of provisions, holding a basket of tangerines.